**PRINT CASEBOOKS 7/1987-88 EDITION**
**THE BEST IN EXHIBITION DESIGN**

*Print*
*Casebooks 7*
*1987/1988*

# The Best in Exhibition Design

Written by
**Edward K. Carpenter**

Published by
**RC Publications, Inc.
Bethesda, MD**

**PRINT CASEBOOKS 7/1987-88
EDITION/THE BEST IN
EXHIBITION DESIGN**
Library of Congress Catalog Card
Number 76-39580
ISBN 0-915734-51-6

**PRINT CASEBOOKS 7/1987-88
EDITION**
Complete 6-Volume Set
ISBN 0-915734-47-8
3-Volume Set
ISBN 0-915734-55-9

**RC PUBLICATIONS**
President and Publisher: Howard Cadel
Vice President and Editor: Martin Fox
Creative Director: Andrew P. Kner
Managing Editor: Teresa Reese
Art Director: Scott Menchin
Associate Editor: Tom Goss
Graphic Production: Jung Hyang Kim

Jurors for the seventh *Print Casebooks/Best in Exhibition Design* looked at thousands of slides representing 205 exhibits to select the 25 exhibits discussed in these pages. It was an arduous task, but as one of them noted, an immensely gratifying one. "Any exhibit designer would consider it a privilege to see these slides," he said, "to have a chance to see what exhibit designers across the country are doing."

The day-long viewing left the jurors with several quick impressions:
• While the general level of exhibit design may be improving, consistent excellence is still elusive.
• Too few exhibits make an effort to integrate type and graphics with an exhibit's mood and form.
• One juror felt and the others concurred that most of the exhibits reviewed lacked a strong central idea—one that could and should shape a successful exhibit.
• The fad for using plants as an exhibit design tool may have gotten out of hand. Many exhibits seem to be using plants as crutches, to fill gaps in form or color that could have been better treated with design.

Whatever the quality of current exhibition design—and on the whole the exhibits that competed for inclusion in this book showed elements of good design—its quantity is unquestionably increasing. Reasons for the increased numbers of exhibits are not hard to find. For one thing, the spate of museum construction that started in the 1960s and '70s continues through the 1980s with no sign of letting up,

creating a flood of new exhibit space. It has reached the point where it seems, as one wag joked, "Every American town of 10,000 persons or more must now have a museum or two and another on the drawing board." In New York City, the country's bellwether museum city, four major art museums are in the throes of extensive expansions or, in the case of the Museum of Modern Art, have just completed a major addition (and there is already talk of MOMA needing still more exhibit space). The Guggenheim Museum plans an 11-story addition to its Frank Lloyd Wright-designed building. The Whitney Museum plans an addition to its Marcel Breuer building. And the Metropolitan Museum of Art is scheduled to open its 90,000-sq.-ft. wing for 20th-century art in 1987.

Science museums and zoos are also creating new exhibit space. Zoos are starting to use exhibits to teach zoo-goers something about the animals they're looking at. San Francisco designer Bruce Burdick points out that TV makes it possible for anyone to watch splendid films of wild animals hunting and reproducing. And these films are available any night in our own living room. In response to this availability of animal image and information and the new attitudes it engenders, zoos are rethinking the way they house and present animals.

The result is more natural and humane zoo habitats, designed with attached exhibits. Here, we discuss three of them (and one botanical garden exhibit). The Cincinnati Zoo's new Cat House has exhibits

that snake through the central part of the house past the inner portions of the peripheral cat habitats. In the San Francisco Zoo's Primate Discovery Center, the monkeys are on the building's periphery but are visible from the central exhibit area. And in New York City's Bronx Zoo, JungleWorld's exhibits are in enclosed spaces along a path that winds through the rain forest habitats. At the Chicago Botanic Garden, an exhibit that tells visitors how plants live and reproduce is in a special space away from the plants.

Another reason so much exhibit work is being done is the continuing schedule of world's fairs. Here, we discuss two examples of world's fair exhibits: "Wonderwall" from the 1984 New Orleans World's Fair, and the U. S. theme exhibit from the 1985 Tsukuba, Japan, World's Fair.

Still another reason for the quantity of exhibit design is an increase in temporary and traveling exhibits. A good portion of this country's new museum exhibit space is being created specifically for temporary exhibits, and indeed most of the exhibits included here—19 of 25—are temporary, changing exhibits.

Corporations, too, are creating permanent and temporary exhibit space. We show three corporate exhibits, one of which—"Tower 75" for the Metropolitan Life Insurance Company—started as a temporary lobby exhibit and ended up as a permanent exhibit gallery. Another, for General Foods, is a permanent exhibit with a special space created by the designers for changing exhibits.

Why this increase in temporary exhibits? In this writer's view, it reflects the need for exhibits, wherever they may be—in corporations, zoos, museums, world's fairs—to compete continually for visitors, not only with each other but also with all forms of recreation. Travel, restaurants, sports, motion pictures, theaters, musical events, videocassette recorders, TV—they are all, in their way, competing for the time and attention of potential exhibit visitors.

A recent Harris Poll showed museum attendance declining slightly, and in light of all this it is not surprising that all types of exhibits—whether their purpose is to instruct, to illustrate, to excite, to inform—also look as if they are trying to sell something.

Weeks after he had reviewed the entries for this *Casebook,* one of the jurors stated, only partly facetiously, that he'd felt he had been sitting through hour after hour of slides of department store boutiques. He felt that perhaps exhibits of all types were being too strongly influenced by marketing.

That may be. But the bias is inherent in the system. Besides competing for attention, exhibits in more and bigger museums and zoos are competing for financial support, for the membership and donations that make possible still more structures, collections and exhibitions.

Of course, some exhibits are *meant* primarily to sell. And we have two examples here of trade show exhibits designed to sell products and to polish corporate images.

As the jurors searched for the best of the submitted exhibits, they leaned toward those whose detailing, color, and design had a seamlessness, a timeless elegance. "Elegant" was one of their favorite words of praise. They leaned away from anything tinged with the colors and seeming impermanence of Post-Modernism. The Post-Modern style they felt was overdone. They eschewed anything that smacked of fad. They preferred the understated and subdued to the bold and brassy. "Lets the artifacts speak for themselves," they said frequently in praise. But in spite of these leanings, examples of exhibits more flamboyant in their elegance show up here. "Wonderwall," the marvelously playful center-piece of the 1984 Louisiana International Exposition, and "Los Angeles 1984: The Olympic Experience," are hardly understated.

This ability of design juries to extract the best of whatever they are searching for, despite the burden of hardened attitudes, preconceptions and idiosyncrasies, is almost uncanny. The selection process is hardly ever easy. Rarely is there unanimous agreement, nor are the choices always made with reasons that can be verbally articulated at the moment of selection. But invariably, the overworked juries do their job with what seems in hindsight like incisive prescience.

This particular jury felt that real excellence in exhibit design is indeed rare. And reasons for this rarity may be found in the profession itself. Exhibit design is taught only sporadically in design schools, if it is taught at all. Most designers come to exhibit design from graphics or industrial design, disciplines that do not necessarily prepare them to envision a space designed in three dimensions. To be successful, an exhibit must fill three dimensions pleasingly, meaningfully and fully, and in light of this it is not surprising that architects are so often successful exhibit designers.

If exhibit designers are largely self-taught, it is understandable that many of the persons they must deal with know even less than they do. "About 80 per cent of my job is educating people I work with," says one exhibit designer. Curators, business people, even other designers have to be reminded what an exhibit designer is doing and why.

Curators can botch an exhibit just as surely as a designer can. A ready example of curatorial-inspired disaster was "High Styles," the exhibit of 20th-century American design at New York's Whitney Museum in late 1985. It had five curators. They all had a different concept for their particular section of the exhibit, and as a result, "High Styles" lacked a focus. Its overall aim, the *Casebook* jurors felt, was fuzzy beyond the abilities of the show's designers—the architectural firm of Venturi, Rauch, and Scott Brown—to remedy.

Money, it seems, is less important than are people to an exhibit's success. A large budget does not insure an exhibit of quality any more than a shoestring budget insures a disaster. Tom Klobe designed

and installed his "2nd International Shoebox Sculpture" exhibit at the University of Hawaii Art Gallery with student and volunteer labor for just under $4000, the lowest cost of any exhibit discussed here, and the Bronx Zoo's "JungleWorld" cost $10 million. The money spent on the rest of the exhibits in these pages was between these two extremes. Five cost $1-million or more, and five cost less than $10,000. It is when budgets are cut back in midstream that design suffers. This rule was broken, however, by one exhibit included here. Charles Moore/Robert Turnbull's "Wonderwall" had its budget slashed from $10 million to $3.8 million, but the designers and their 2500-ft. wall survived the shock.

Often, when budgets are cut, exhibits will drop costly computerized equipment. Several designers of these exhibits said they would have included more computerization if the budget had allowed it. And money may be one reason there is no evidence here of anything technically innovative. Only seven of the 25 exhibits used computers in any form, and most of these were for touch-screen information recall.

But if the exhibits here show no sign of technological innovation, at least one made use of mechanical invention. The designers of "Circles of the World" at the Museum of Fine Arts, Boston, designed a special hydraulic lift that let them lower a temporary gallery's partition walls to the floor, where they became exhibit platforms, saving time and money.

Despite a heightened respect for what exhibit design can achieve, despite vast sums spent on it, and despite a relatively high level of overall exhibit design, there seems to be little communication between the architects who build the structures to house exhibits and the men and women who design them. Part of the agreement Rosenthal & Associates had with the Tsubuka, Japan, World's Fair when they won the competition to design the U.S. theme exhibit was that they would work with the building's architect to see that the building interior suited the exhibit. As it worked out, perhaps because the architect was in Japan and the designers in the U.S., the building was designed and constructed before the exhibits were, and there was no chance for coordination. The structure, a marvelous flowing tent, happened to house the exhibits well, but this after-the-fact situation that hampers exhibit designers has become a sad tradition at world's fairs. Unfortunately, that lack of coordination is also seen in museums and zoos. In an era when so many structures are being built to house exhibits, it is sad that the exhibit designer has so little chance to work with the architect to establish the need for electrical placement and light, let alone to coordinate the shaping of special spaces.
—*Edward K. Carpenter*

## Thomas J. Wong

**Casebook Jurors**

Currently in his 16th year as Museum Designer at Boston's Museum of Fine Arts, Thomas Wong has not only been involved with specific public exhibits, but was appointed to develop liaison with the office of I.M. Pei architects in developing gallery renovations and the re-installation of the permanent Asian art collection as well as the installation of special exhibition spaces in the museum's new west wing. During his 30 years of experience in exhibition organization, design and planning and project management, his emphasis has been on institutions, museums and fine arts galleries and related architectural, mechanical and electrical solutions directed toward effective special installations and presentations. In 1979, he designed and organized the MFA's museum at Faneuil Hall Marketplace, Boston, where commercial space was developed for use as an "in-town" popular museum while major construction projects required closing large sections of the main museum building. In 1985, he was appointed to design and develop an overall plan for the rehabilitation of a 19th-century school building for conversion to a National Plastics Museum, which will serve as a study and exhibit center for the U.S. plastics industry.

## Joe Sonderman

Joe Sonderman, president of Design/Joe Sonderman in Charlotte, North Carolina, is a 1961 graduate of the University of Cincinnati with a BS in industrial design. Beginning as a student exhibit designer in Cincinnati, he later joined Chrysler Corp. in Detroit in automotive styling and served successively as staff industrial designer with Sylvania, Thomas Lowes Associates and Brockway Glass Co. In 1966, he joined the Charlotte firm of Pentes and, as vice-president/ design director, was responsible for such projects as the Dixie Crystals Disney World exhibit and Drexel Enterprises furniture market showrooms. His membership in professional associations includes the AIGA and Industrial Designers of America, where he serves on the national ethics advisory committee. His work has been recognized with awards from, among others, the New York Art Directors Club, IDSA, Communication Arts and ID magazines, and *Print Casebooks*. Founded in 1972, Design/Joe Sonderman has served cities throughout the Midwest and the East. The scope of projects ranges from corporate identity, product development and packaging to exhibit and graphic design for museums and zoos.

## Nancye L. Green

Nancye Green is involved in a wide variety of media, from environmental design, advertising and print graphics, to computer-driven multi-image presentations, film and video. Since 1974, when she founded Donovan and Green with her partner, Michael Donovan, the firm has grown to more than 50 designers, producers, writers and administrative staff. During this time, Green worked as an art director and media producer, managing communications programs and creating and staging events and presentations around the world. Her firm's corporate clients have included AT&T, Exxon, IBM, Formica Corp., Brickel Associates, Herman Miller, ABC, and American Express. Earlier, she acted as a consultant to the development of the National Endowment for the Arts' Architects-in-the- Schools Program, and lectured extensively on her work in advocacy planning/design education. Green graduated from Newcomb College of Tulane University in 1968 with honors in Urban Studies. After working for Time Inc., she attended Parsons School of Design, graduating *cum laude* in Environmental Design in 1973. Since then, she has taught and lectured at a number of educational institutions and currently teaches graphic communications at Cooper Union.

## Ralph Appelbaum

Ralph Appelbaum is president of Ralph Appelbaum Associates, a New York-based firm specializing in exhibit and environmental design as well as long-range planning for museums. After receiving a Bachelor of Industrial Design degree from Pratt Institute, Appelbaum was for three years a design advisor in the Peace Corps and for the U.S. Agency for International Development in Peru. Back in the U.S., he directed a federally-funded program in conjunction with the Industrial Designers Society of America to design products suitable for manufacture by the disabled. Later, he joined Robert P. Gersin Associates and then Raymond Loewy International, where, as vice- president of exhibits and museum environments, he was responsible for the nation's largest Bicentennial project, the "Living History Center" in Philadelphia. In 1978, RAA was founded as a multi-disciplinary team, specializing in three- dimensional and audiovisual communications programs in the sciences and humanities. It has completed over 60 major projects, many of which have won awards. Appelbaum is an assistant professor in the museum studies department at New York University and was for five years a visiting professor at Pratt.

## Robert P. Gersin

Robert P. Gersin has been president and design director of RPGA since he founded the company in 1959. Under his guidance, the firm has acquired an international reputation for excellence in a wide range of graphic design, corporate identity programs, product design, exhibition design and specialized architecture. These projects include related contributions in research, product positioning and long- range planning for such clients as national and international corporations, many branches of government, museums and hospitals, professional groups and non-profit organizations. RPGA has received over 350 national and international awards for projects in all of its design categories. Gersin, who holds a number of mechanical and design patents both in the U.S. and abroad, received a Bachelor's degree from the Massachusetts College of Art and a Master's in design from Cranbrook Academy of Art. Later, he was awarded an honorary doctorate from MCA. After his formal design education, Gersin became a commissioned officer in the U.S. Navy, working for three years in a design capacity for the office of naval research. Among his most innovative projects was a unique, private video communication system he designed for use by the president and the secretary of state.

## Casebook Writer

### Edward K. Carpenter

Edward K. Carpenter writes extensively on architectural and design subjects, and was for many years an editor with national magazines in these fields. He is the author of several books on various aspects of design. This is his sixth *Exhibition Design Casebook*.

## Index

### Exhibitions

## Clients/Sponsoring Organizations

## Design Firms/Designers Consultants/Curators

"Reflex" was the name the newly-formed Analytica Corporation gave to its line of database computer software. Reflex's first exposure to the trade was at the Comdex trade show in Las Vegas, where to stay in business the company had not only to sell some software, but also line up dealers to help them sell it.

Obviously, the Analytica exhibit had to attract attention, and the instructions given to Mark Anderson Design, of Palo Alto, California, the firm asked to design it, were to make it exciting and memorable. But most important, said the client, was that it not be designed with a massive structure that would overwhelm the product. The assignment was a seeming paradox: design an exhibit striking enough to lure people, but subdued enough to disappear once visitors were inside.

Like all insightful ideas, the solution was so appropriate it seems inevitable and simple. Designer Mitchell Mauk, senior designer with Mark Anderson Design, recalled the light thrown by reflector umbrellas in a professional photo session. The light had a special, emotionally appealing quality, and Mauk thought he could give the Analytica exhibit that quality on a grand scale. (The

Analytica space was 1000 sq. ft.) At first, he thought of constructing towers of reflector umbrellas. But the umbrellas leaked light around their edges and seams, spoiling the quality, and no matter how he positioned his lights, the scaffolding threw shadows on the umbrella fabric. He realized that, to make the umbrellas work, he would have to modify them, and that the modification would be expensive.

Instead, Mauk switched to a system of rectangular steel tubing (1½″ by 1″) and ¼″ round steel rods covered with white ripstop nylon. By positioning the rods within the steel tubing framework, he created pyramid shapes, elevating the pyramid tips about 6″ above the surface plane. The designers clamped the nylon to the steel frames, and then built light towers in 3′-square modules, stacking and juxtaposing them to achieve 9′- and 12′- heights and 6′-to-9′- widths.

Inside each of the exhibit's towers were four 1000-watt quartz halogen spotlights, two at the top projecting down from a steel support bar, and two at the bottom shining up. Enough light bounced around and diffused through the nylon panels to suffuse the entire Analytica area in a soft glow.

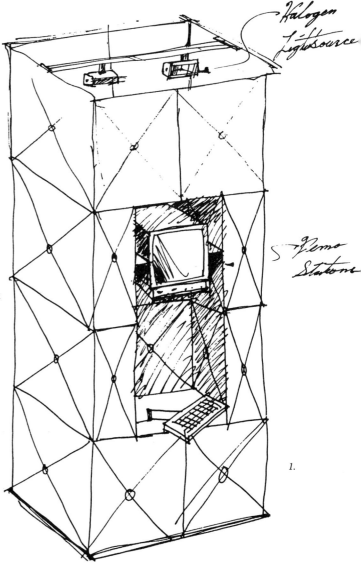

1.

*1, 2. Sketches of Analytica Corp.'s interiorly lighted, fabric-covered steel frameworks. These held video screens that showed Analytica's computer software.*
*3. Rendering of exhibit layout.*

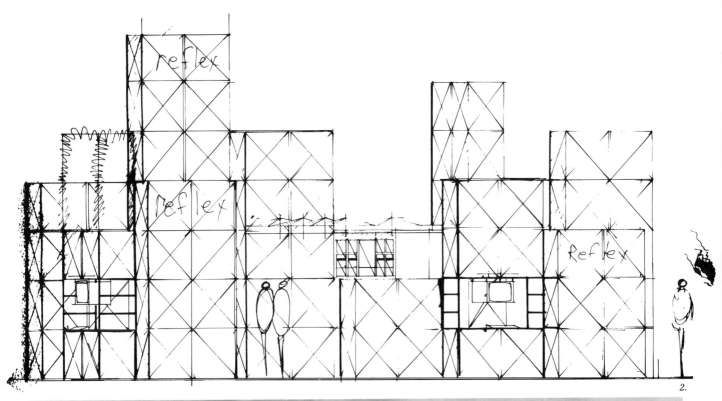

2.

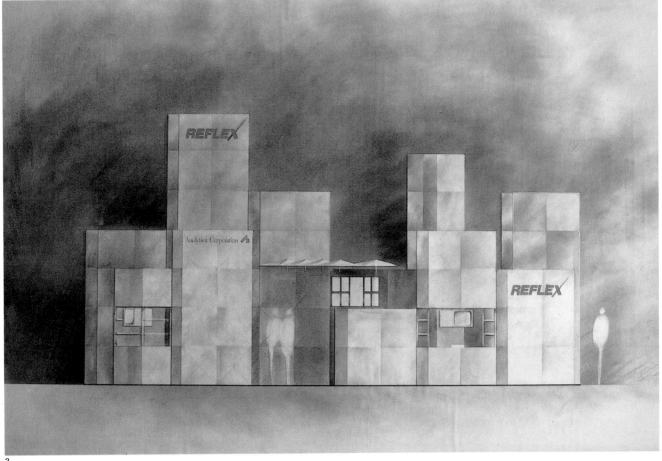

3.

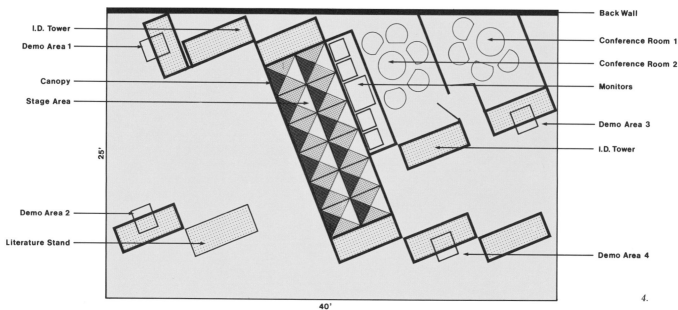

I.D. Tower
Demo Area 1
Canopy
Stage Area

25'

Demo Area 2
Literature Stand

40'

Back Wall
Conference Room 1
Conference Room 2
Monitors
Demo Area 3
I.D. Tower
Demo Area 4

4.

Seen from across the exhibit hall, "it was as if an encounter of the third kind was going on," says Mauk.

And people were indeed drawn to the exhibit. Analytica was able to sign up 150 dealers, 50 more than they had hoped for.

Inside, the exhibit *did* tend to disappear. Demonstrators presented the Reflex story on a stage against a wall of nine video monitors, beneath a tent-like canopy of black nylon pyramids 9' overhead. And salesmen worked with visitors in two conference rooms, surrounded by hollow-cored corrugated plexiglass panels 4' by 11' that let in light but provided privacy.

The exhibit area contained a dark red back wall, a gray carpet and four demonstration areas—in front of computer terminals and keyboards (supported on white steel rods) in open plywood cabinets (6' high by 3' wide) laminated with

white Formica, set into four of the steel frame and nylon towers.

Graphics were minimal: only the name Reflex at the top of the towers in Helvetica typeface, the *x* in Reflex crossed by a red neon tube, and beneath that, in much smaller Bodoni type, the Analytica Corp. logo, and a few small, jewel-like (6" square), bright-red quote panels.

Mark Anderson Design had the exhibit in place in four months on an exhibit budget of $65,000.

Mitchell Mauk was pleased with his light experiment. "When you put light into an exhibit space," he says, "the space comes alive, and if you use enough, it attracts people." He especially liked the way his diffused high-intensity light gave a "calm, soft, inviting aura" to an exhibit devoted to an essentially hi-tech computer product.

*4. Exhibit floor plan.*
*5. Video monitors set on white steel rods in tubular steel and fabric modules.*
*6. Conference room behind corrugated plexiglass panels.*

**Client:** Analytica Corp. (Scotts Valley, CA), now owned by Borland International
**Design firm:** Mark Anderson Design, Palo Alto, CA
**Designer:** Mitchell Mauk
**Fabricator:** Barr Exhibits

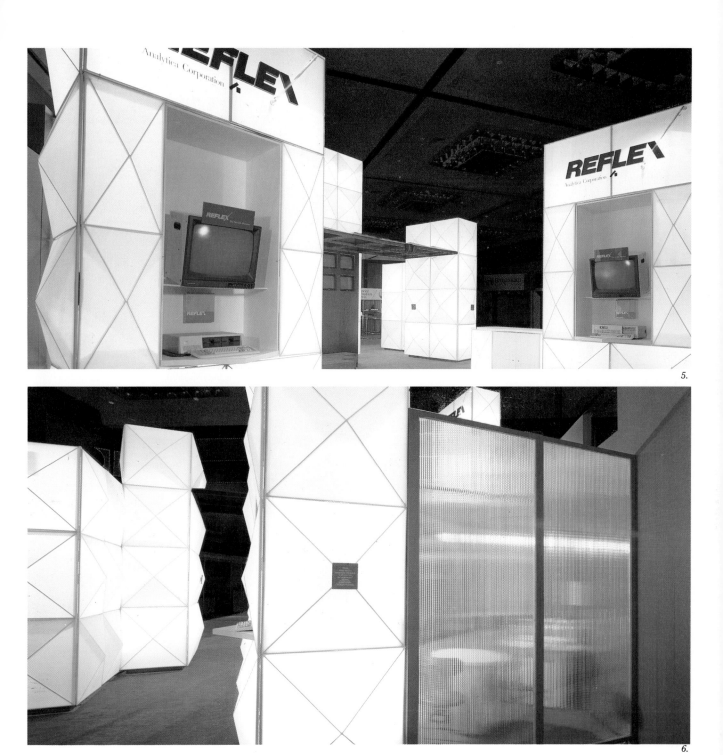

5.

6.

For three months, New York's American Museum of Natural History displayed nine mammalian skeletons. Two were of once-famous racehorses, one of a draft horse pulling a heavy load, one of a rearing horse with that of a man seeming to reach for the bridle, one of a wild horse chased by a wolf, one of a Russian wolfhound, one of a donkey. What set the skeletons apart from others was that they represented the work of S. Harmsted Chubb, who had spent his professional career putting together mammalian skeletons, assembling the bones so that the completed skeleton looks as if it was frozen in the midst of motion. Chubb was an associate curator at the museum during the first half of the 20th century (he died, at age 85, in 1949), and besides assembling amazingly accurate, beautiful skeletons, he advanced the incipient art of photographing animals in motion.

Designed for the museum by Ralph Appelbaum and Associates, the temporary exhibit took a look at the history and current status of animal motion study, as well as at Chubb and his frozen-in-motion skeletons.

The exhibit contained photomurals of Chubb's photographic studies, and photomurals of Eadweard Muybridge's motion photographs, which were a basis for Chubb's. A case held

# CAPTURED MOTION

Skeletal Studies by S. Harmsted Chubb

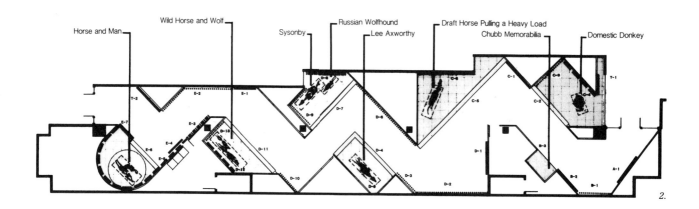

1. Exhibition logo.
2. Floor plan.

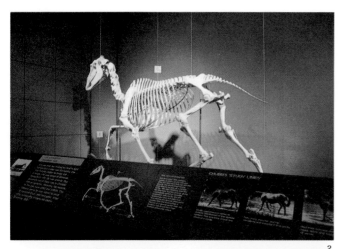

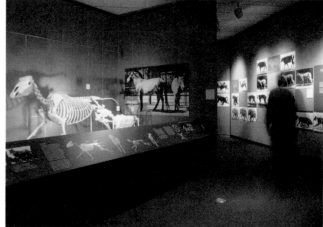

5.

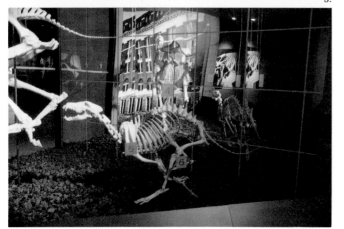

4.

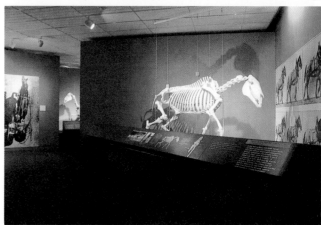

6.

3, 4, 5, 6. Exhibit displayed skeletons arranged by S. Harmsted Chubb to show mammals in motion.
7. Diagram of race horse skeleton.

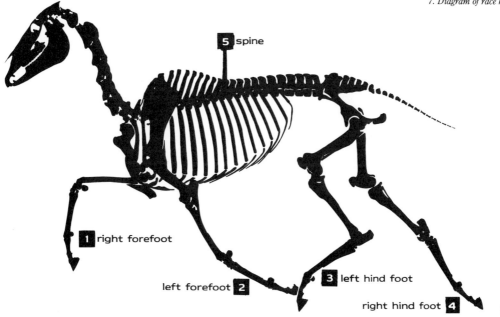

**5** spine

**1** right forefoot

left forefoot **2**

**3** left hind foot

right hind foot **4**

7.

tools and personal items, and at the end three video monitors showed current work on animal motion. But the exhibit's main focus was the skeletons themselves, and everything the designers did with traffic flow, color and light served to highlight the skeletons. "The designers helped the subject dominate," noted the *Casebook* jurors. Partitioning the 27'-by-140' gallery with ½" Masonite walls in a zig-zag pattern, the designers positioned the skeletons so that, as a visitor rounded a corner, he confronted another skeleton caught in motion.

Each of the extremely delicate skeletons came on its own furniture-like, polished mahogany-base mounting, and to protect these mounts as well as to raise the skeletons further off the floor, the designers prepared platforms at each skeleton position and had the skeleton mounts lowered into rectangular cutouts in these platforms. As a result, each

skeleton stood about 18" off the floor.

On the floor in front of each skeleton were particle-board wedges, laid down in 17"-by-48" modules. The front faces of these wedges, slanting back toward the skeletons at 45-degree angles, became mounting surfaces for photos, diagrams and text.

Colored markers (2½" acrylic squares), spray-lacquered in either green, gold, blue, orange or purple, identified specific bones in each skeleton. These squares, which had a central hole, slipped onto strands of ³⁄₁₆" stainless-steel aircraft cable, hanging from a ceiling-mounted bar running parallel to the skeleton's spine, and locked in place next to the bones they were to pinpoint. Colors and numbers on the tags correspond to explanatory graphics and text on the floor wedges.

Openings in the backs of the wedges let out light from low-voltage pinpoint spots, mounted

on interior shelves. The spots illuminated the skeletons, throwing shadows on wall grids behind them. Silk-screened on 4'-by-8' Masonite sheets and mounted on the wall studs, these grids had 18" squares. They were inspired by Muybridge, who used grids in his early motion studies and, in this exhibit, were meant to catch shadows and give a sense of proportion. Besides, the grids "created a drawing class environment," says one of the Appelbaum designers, "and Chubb always encouraged people to draw his skeletons." To nobody's surprise, the museum found that many visitors did indeed sketch the skeletons.

Even though the skeletons were positioned against walls and no one could walk around them, wall-mounted mirrors gave viewers various perspectives.

The designers attached graphic panels, some 36" by 36", and caption panels, 7½" by

7½", on ¼" Masonite, to walls and to the floor wedges with Velcro strips.

Colors throughout the hall were in keeping with the color of the skeletons' bones. For instance, introductory panels were an off-white with dark gray type. And graphic panels were dark gray with off-white type and illustrations. The designers used a warm dark gray on the walls, and the grids behind the skeletons were black and orange.

ITC Newtext was the typeface for text labels and captions and American Gothic Demibold (all capitals) appeared in titles.

In its three-month run, the exhibit drew 150,000 visitors.

**Client:** American Museum of Natural History (New York City); George Gardiner, chairman, Exhibitions and Graphics; Marie A. Lawrence, senior scientific research assistant, Mammology Dept.
**Design firm:** Ralph Appelbaum Associates, New York, NY
**Designers:** Ralph Appelbaum, Gloria Caprio, Scott Simeral, Francis O'Shea, Stephen Schlott, Cheryl Filsinger, John LoCascio, Adam Levinson
**Fabricators:** American Museum of Natural History; Xylem Design and Fabrication

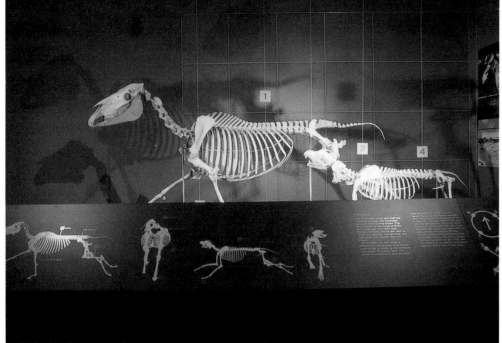

8. *Exhibition lighting threw skeletons' shadows on wall grid. Grid could be used in sketching the skeletons.*

8.

# Plant/People Partnership

Since opening in 1975, the Chicago Botanic Garden, under the landscape and design stewardship of Jeff Rausch Environmental Design and Planning, has consistently paid close attention to esthetics. One of the nice things about designing an exhibit for the facility, says Jane Bedno of Bedno/Bedno, the Chicago design firm that created a permanent introductory exhibit for the Garden, "was that it was just mutually assumed that whatever we did we would design to suit the Garden's esthetics."

What the Botanic Garden wanted was a permanent exhibit for a specific 3700-sq. ft. exhibit space that would introduce visitors to plants, tell them something about how plants live and reproduce, and ultimately—in a second design phase—show them how plants and people need one another. The Garden raised $190,000 for the first phase, and fundraising is underway for the second, which will roughly double the exhibit's size, though the space it fills will stay the same.

Obviously, the exhibit had to be one that could fill the space even when it was only half its eventual size; and more than that, it had to fill the paradox of being permanent while being capable of being removed and stored every weekend when the Garden's exhibit space is taken over by garden club plant and flower displays.

The Bedno/Bedno solution is a series of nine closet-like kiosks (9′ 8″ high by 4′ by 4′) with hinged covers that swing open on two sides like unfolding flowers to become display

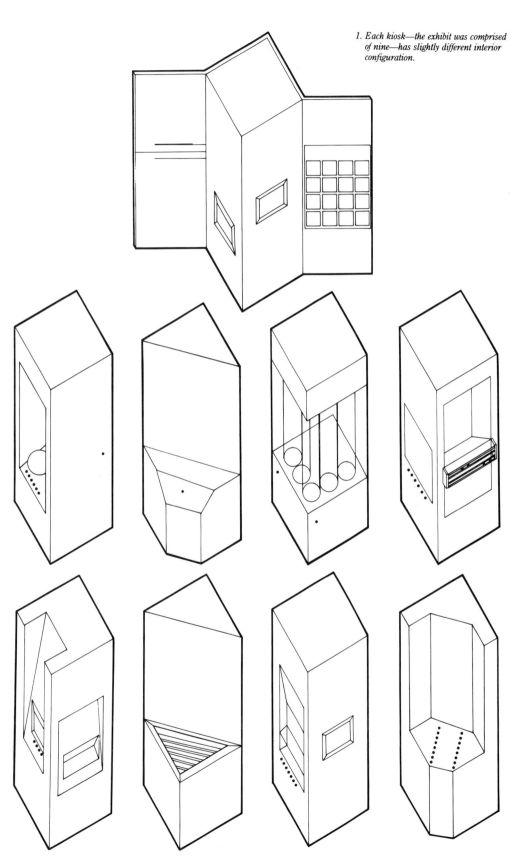

1. Each kiosk—the exhibit was comprised of nine—has slightly different interior configuration.

surfaces. Each kiosk explains a different botanic concept, eight in all: variety, anatomy, roots, seeds, photosynthesis, stems, pollination, and propagation. The box's center portion is a display case for three-dimensional exhibit devices, such as models of plants, or a housing for video screens and electronic devices, like the one where a visitor pushes a button to see if he can match a flower with its pollinating mechanism. Each unit has one or more interactive devices. One kiosk has a computer heredity simulation, another an electronic simulation of plant growth and function. The electronic devices were all purposely kept very low-tech to avoid breakdowns in the damp Botanic Garden environment. Dampness, it turned out, was one of the lesser annoyances the designers had to work around. More challenging was the uneven tile floor which rises and falls as much as three inches in three feet to accommodate a host of drains.

By putting their display kiosks on casters (four for each), the designers made them movable. And adding mechanical levelers made it possible to keep the cabinets straight regardless of their position in the exhibit space.

Built with Ventwood exteriors—a dowel and slat wood construction which lines the walls and ceiling of the exhibit hall—and plastic laminate liners, each cabinet weighs several hundred pounds, including its lighting displays and wiring. But each is sufficiently easy to handle to be folded up and pushed to the side of the hall (where it blends

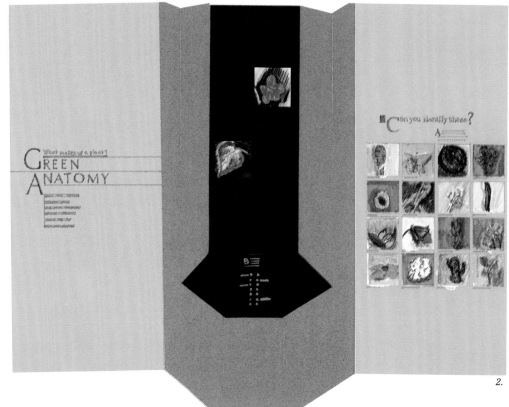

2.

3.

2. Final "appearance" design (preceding final working drawing) illustrates how kiosk's folding doors open to become graphic display surfaces.
3. Exhibit scale model shows how closed kiosks may in future be used for table system of display.

4.

5.

with the walls) by two petite women.

In addition to a 1″ scale model of each cabinet, the designers built a full-sized prototype, which they positioned in the hall temporarily while they asked visitors and staff for comments. As a result, they beefed up leveling devices, casters and hinges holding each unit's wing-like door-display surfaces.

With their doors open—stretched to either side of the core—the units are flower-like in their range of colors: blues, greens, yellows, reds. The designers selected inner-surface plastic laminates for their colors—when open and exposed, these inner surfaces give the cabinets a full width of 13′ 6″—and on the inner surfaces they mounted color photos of flowers and plants to provide still more color. Type is silkscreened on each unit in two colors. Optima is the typeface, since the Garden was already

6.

4. With folding doors shut, kiosks can be stored at side of hall against Ventwood walls.
5. Graphic panel.
6. Exhibit kiosks on casters set in place beneath Ventwood ceiling.

using it, and the designers found it worked well for them. "It's a graceful, flexible classic face," says Jane Bedno.

Lighting comes mostly from a central skylight in the square-domed ceiling, but occasional cabinets have pinpoint lights for special situations.

Eventually, once more funds come in, the cabinets will serve as attachments and backdrops for a table system for flower shows. Tables will hook into keyhole slots in the kiosk's backsides.

Bedno/Bedno designed the exhibit over two years on an overall budget of $190,000.

**Client:** Chicago Botanic Garden
**Sponsoring organization:** Dart Kraft Foundation
**Design firm:** Bedno/Bedno, Inc., Chicago
**Designers:** Jane Bedno (project director), Ed Bedno (designer), Tabitha Bedno (project coordinator), Marjorie Boccio (graphics), Andrew Bedno (computer programmer)
**Consultants:** Chicago Botanic Garden staff and volunteers: Susan B. Brogdon, Nancy Race, Randi Korn, Linda Lutz, Betty Bergstrom
**Fabricator:** Eurodomestic

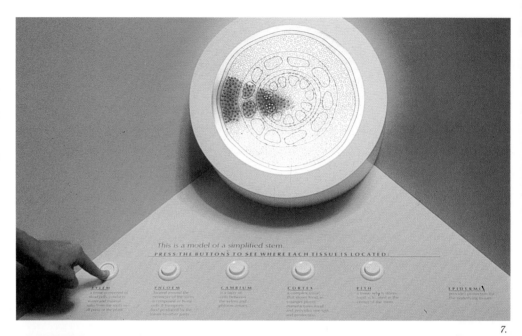

7.

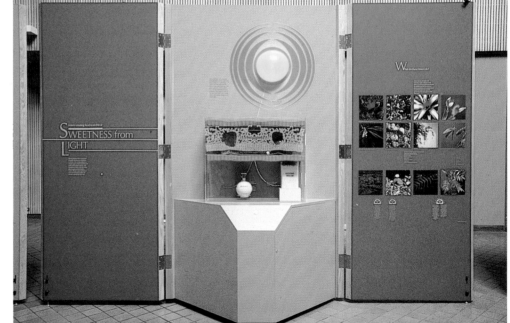

8.

7. Visitor pushes buttons to identify parts of stem cross-section.
8. Visitors can activate an illuminated photosynthesis sequence. Mechanical levelers hold kiosks steady on tile floor.

# Primate Discovery Center

The Primate Discovery Center at the San Francisco Zoo is the first of what will be a series of buildings, grouping animals outside around the buildings' periphery, and presenting information about them in interior central exhibit areas.

In the Primate Center, this central area consists of 1500 sq. ft., and the exhibit designers, San Francisco's Burdick Group, realized that the primates on display, romping in large exterior pens, are formidable competition for any static exhibit. Moreover, they knew from experience that single, isolated exhibits positioned next to a particular zoo animal tend to be ignored. So they grouped the exhibit elements—17 in all—knowing that these would have more allure as an ensemble. Then the designers set out to make the elements individually appealing as well.

Each of the 17 exhibit elements is an erect compound of geometric shapes—circles, squares, rectangles, diamonds —and a medley of subdued colors—soft purples, yellows and beiges.

Bruce Burdick calls the elements "furniture," and indeed, in a bizarre way, they resemble shapes we might associate with bureaus, tables and bathroom scales. Even their size is that of furniture. The largest of the shapes is 9′ high by 3′ deep by 8′ wide. Their interior steel structure protects the game mechanism each houses as well as provides support. Each has a fiberglass base and laminated wood facing. Because the doors around the exhibit are open and San Francisco fogs can roll through

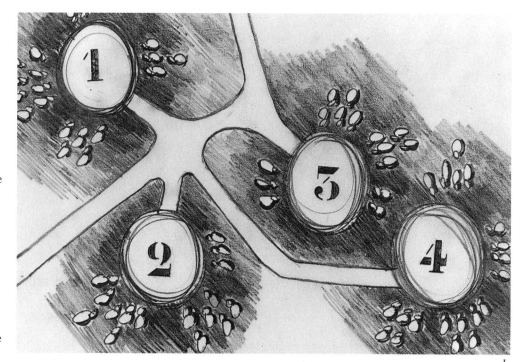

1.

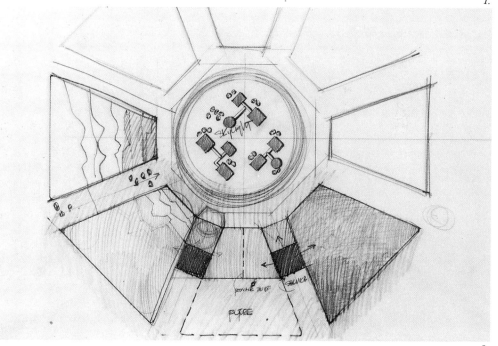

2.

1. *Plan proposes several Discovery Centers with animals around them.*
2. *Discovery Center plan with exhibits in center and animals on the perimeter.*

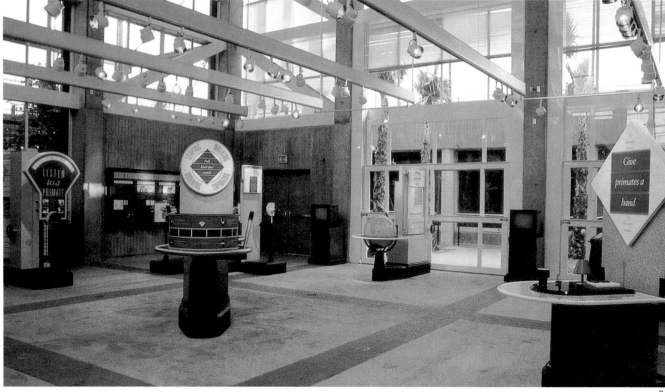

the Primate House, the devices have aluminum and stainless steel parts.

This "furniture" offers an enticement of buttons and wheels that a visitor can manipulate to find out about primates. "Our aim," says Bruce Burdick, "was to acquaint visitors with the fact that they, too, are primates and to develop information devices that would improve the visitors' viewing and understanding of the primates in the zoo."

Visitors can use the machines, which are essentially computer games, to construct a primate, for instance, or to answer questions they may have about the animals they've

seen. (Each type of primate in the Discovery Center has a number and visitors can punch corresponding numbers on the machines for specific information.)

Using full-scale mockups, the designers determined final sizes and positioning and decided how big to make type and graphics.

For typefaces they selected Sabon, because they felt it is both elegant and friendly, and, for high visibility at a distance when the face is tilted, Univers 49.

Design of the Primate Discovery Center's exhibit grew out of a study the Burdick Group undertook, starting in 1981, to determine how the San

3. *Handsome interactive devices lure visitors in hopes of teaching them something about primates in Discovery Center.*
4. *Exhibit device illustrates the different types of primate hands.*

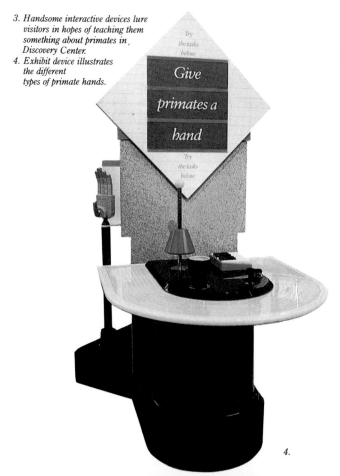

Francisco Zoo, and zoos in general, will grow and change. In an era when wild animals can appear nightly on TV films in everyone's living room, the Burdick Group felt that zoo visitors need access to specific information about the animals they are seeing. And they feel that displaying animals in very particular groupings may help visitors learn. So future Discovery Centers at the San Francisco Zoo may focus on a particular topic rather than a specific species. Housing a snake, a kangaroo, a hippopotamus and a hummingbird together, for example, might make it easier for visitors to learn about locomotion.

San Francisco Zoo authorities figure attendance is up 36 per cent since the Primate Discovery Center opened.

Overall exhibit budget was $450,000, including computer elements and software.

The *Casebook* jurors especially liked the way the exhibit draws you in and gets you involved with the information.

**Client:** San Francisco Zoological Society
**Design firm:** The Burdick Group, San Francisco
**Designers:** Bruce Burdick, Stephen Hamilton, Eric Anderson, Nancy Olexo, Bill Chiaravalle, Richard Antaki
**Fabricator:** General Exhibits and Displays, Inc.

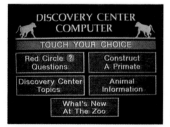

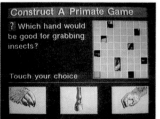

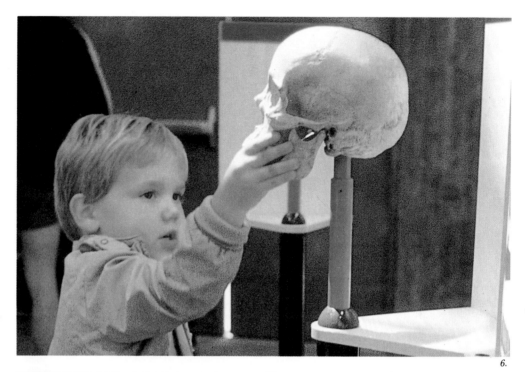

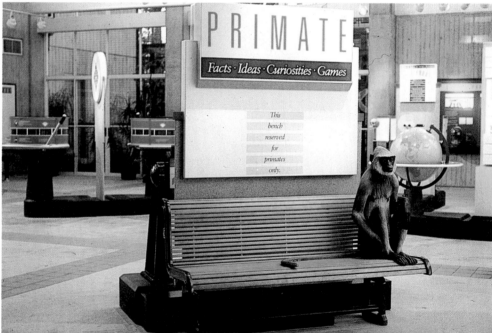

5. *Touch panels let visitors call up information, shown on video screens.*
6. *Visitors of all ages are allowed a hands-on exploration of exhibits.*
7. *Entrance seating is only for primates.*

# Cat as a Hunter

Zoo director Edward Maruska had a clear idea of what he wanted to display in the redesigned Cat House at the Cincinnati Zoo. First would be the cats themselves—leopard, lynx, serval, jaguar, ocelot, jaguarundi, margay, bobcat—gathered from deserts, forests and jungles around the world. Second would be an exhibit explaining to visitors that the cats they were looking at were not like their tabbies at home, that the cats in the zoo's Cat House were wild hunters, that much of their behavior—even when it seemed like play—was related to killing. This second exhibit would be in the interior of the redesigned Cat House, to

be visited after the zoo-goers had passed by the cats themselves, lounging or roaming in simulated real environments on the periphery of the building, some inside, some outside.

The old Cat House at the Cincinnati Zoo had been built in an era when zoo animals were housed less humanely than they are today. "It looked like a prison for cats," says Robert Probst, of Schenker, Probst + Barensfeld, the Cincinnati design firm that designed the "Cat as a Hunter" exhibit. More than that, he says, the old Cat House smelled so badly that visitors were avoiding it.

Now, the cats are mostly

outside, at least in good weather, in fine mesh-screened pens just beyond the building, or in large (20′ by 25′ and 25′ by 50′) cages, landscaped with simulated rocks and vegetation, that extend into the building from the outside. In the building's center is the Schenker, Probst + Barensfeld exhibit. Light comes into the exhibit space through the 1½″-thick plate glass walls that are the inner ends of the cat cages, and it was one of the designers' most difficult tasks to keep the exhibit lighting from throwing reflections onto the glass, interfering with visitors' views of the cats.

The designers' solution to

this problem was to use pinpoint spots focused directly on the text or graphics of their exhibit and to keep the general light level subdued.

The exhibit is as exact as its lighting, depicting its theme and related cat information with images that are never abstract. That naturalness was the way zoo director Maruska envisioned it; and if his vision seems strict and inflexible, it was not. The designers had worked with Maruska before, designing a corporate identity program for the zoo, and he simply went to them, asked them to design the exhibit he had in mind on the cat as a hunter, and instead of handing

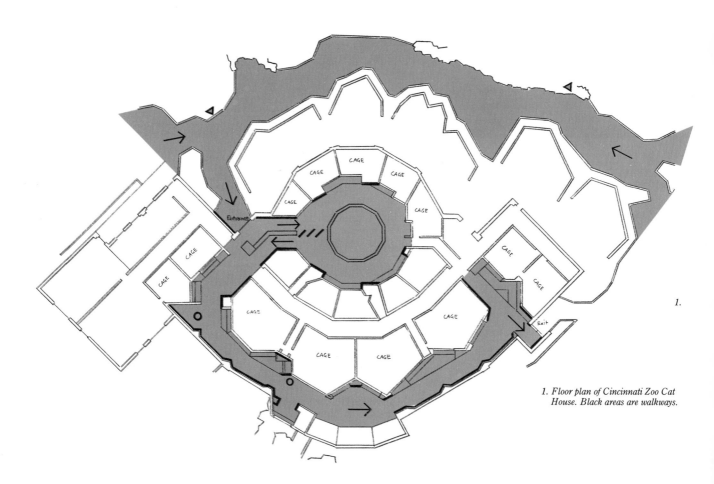

1.

1. Floor plan of Cincinnati Zoo Cat House. Black areas are walkways.

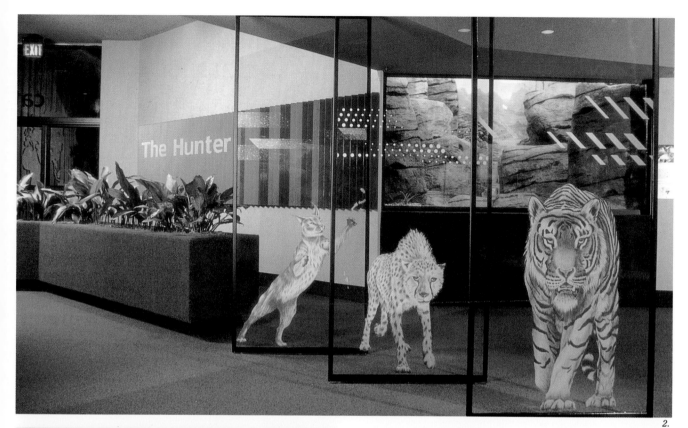

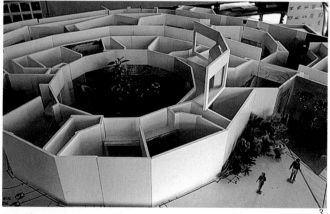

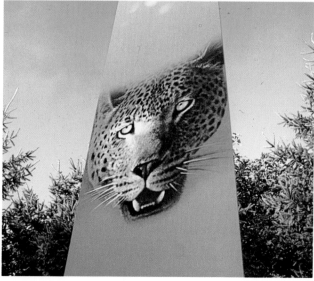

2. Cats silkscreened on clear dividers keep
   visitors on the path.
3. Open ½" scale model of Cat House and
   exhibits.
4. Cat image on exterior identification
   pylon.

them a budget, asked them what it would cost.

While this trust might seem tantamount to presenting Schenker, Probst + Barensfeld with a blank check, they maintain it actually made them pay stricter attention to costs. Once they had set a program, they elicited very detailed bids from suppliers and contractors.

The exhibit's final details, says Bob Probst, "grew out of a series of work sessions with designers and zoo administration," and in its completed form the exhibit gives visitors a good deal of information with striking simplicity. For instance, a world map with figures of wild cats silk-screened on it shows where various species live. Another wall graphic identifies cat species. (The zoo has 16 different live species in residence.)

In all, the explanatory exhibits have 3500 sq. ft. of space, and their design leads visitors sequentially from the entrance clockwise around a centrally skylighted rotunda with a central planter and then along what is essentially a wide corridor to the exit.

This corridor has three alcoves, which house exhibits requiring visitor participation that goes beyond mere reading of the text. One is a wall-mounted plexiglass sheet, 12′ long and 9′ high, with push-buttons set into it. Pushing a button lights up a special part of a lioness's skeleton on the plexiglass. Its claws are illuminated, for instance, or its skull or spine. And explanatory text silk-screened on the plexiglass is lighted simultaneously.

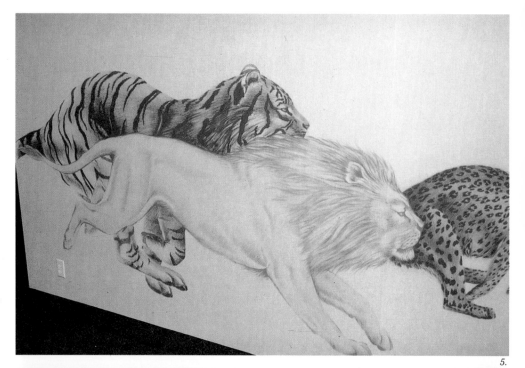

5.

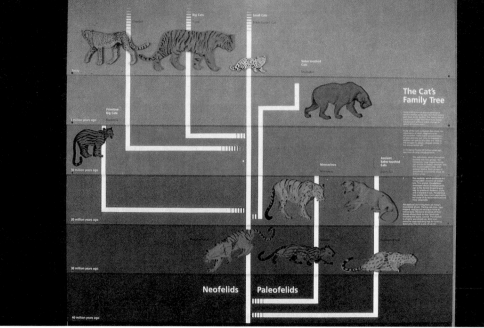

6.

How Far
Can a Cat
Jump?

12  11  10  9  8  7  6  5  4  3  2  1

7.

Limiting
Conflict

8.

*5, 6, 7, 8. Wall graphics inside Cat House*
*illustrate cats in motion and teach*
*something of their lineage and*
*characteristics.*

Another alcove holds a computer terminal (25″ diagonal) and keyboard, programmed to give a comparison between human population densities in a city and the densities of cats and antelope on a savannah.

A third holds a double cylinder (18″ in diameter and 12′ tall) which visitors can rotate to line up three cat species on the outer plexiglass cylinder with environments on the inner plexiglass. Against some environments, some cats stand out; against others, they disappear.

Elsewhere, a somewhat similar cylinder, one within another (24″ by 48″), has ascending and descending stripes, which seem to move up and down as the cylinder rotates, something like a two-way barber pole. Colors of the stripes relate to the food chain, with predators (cats) at the top and vegetation at the bottom.

Instead of walling off space to create a small theater, the designers made use of a wide space in the corridor, setting up a large-screen TV and covering raised-seating platforms, which were part of the architectural plan, with carpeting. Here, a continuous loop tape plays films of large cats hunting.

Visitors entering the building are guided clockwise around the rotunda by a planter that blocks their path to the right, and once they have circled the rotunda's exhibits, they are kept from going around twice by cats silk-screened on staggered glass panels 12′ to 15′ high, framed in steel and fastened to floor and ceiling. The cats here are the result of three silk-screening steps, one for dark

9. *Popular wall display shows outline of
leopard with part artificial and part
real fur. Those touching it could tell
little difference between real and fake.*
10. *Plexiglass tube holds skulls
illustrating development of extinct
saber-toothed tiger.*

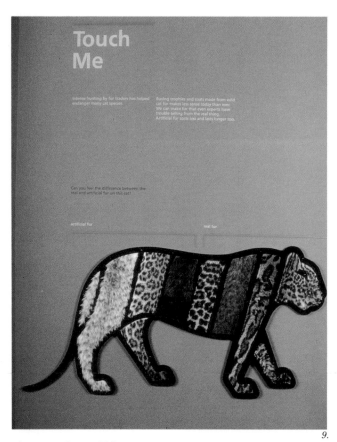

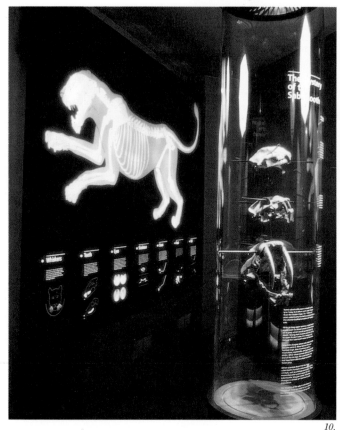

9.

10.

colors, one for a middle screen of light colors that shows textures, and one for a silhouette. The textured layer shows through from both sides.

It is no surprise that one of the exhibit's more popular displays is one that is meant to be touched. A wall-mounted cat silhouette has real fur at one end and artificial fur at the other. Visitors are encouraged to touch the furs to see how amazingly similar they are. Why, the caption asks, kill cats for their fur when the artificial is so much like the real thing? The fur (real and artificial) wore out from all the touching and soon had to be replaced.

Finally, the exhibit contained a five-panel photomural (10′ by 6′) of various cats in their natural environments. After all the exhibit's displays of ecology and cat anatomy and evolution, the mural was a reminder that along with everything else, the cats are beautiful and that fact alone is a reason to preserve them.

Schenker, Probst + Barensfeld did all the exhibit's signs, including the pylons (12′ by 2½′) that guide visitors into the Cat House exhibit.

They specified Frutiger typeface for all descriptive and interpretive texts and Garamond for literary quotations.

Plants throughout the exhibit were chosen by the zoo's horticultural department to depict those found in some habitats frequented by cats.

*Casebook* jurors felt the Cincinnati Zoo's Cat House was the best of its type that they reviewed. They praised its spirit, but several thought the design quality uneven. And in a year when the jurors were forced to look at too many bad exhibits in which plants were used as crutches, the jurors felt the plants detracted even from this exhibit.

**Client:** Cincinnati (OH) Zoo; Edward Maruska, director
**Design firm:** Schenker, Probst + Barensfeld, Cincinnati
**Designers:** Heinz Schenker, Robert Probst, Mark Barensfeld (design directors); Chris Walden (illustrations); John Getz (copywriting); Laura Jones, George Connett, Gary Sankey, Dave Oka, Chris Danemeyer (staff)
**Curator:** Barry Wakeman
**Architects:** Glaser and Myers, Inc. (Mark McCollow, Russ Myers)
**Consultants:** David Manwarren Corp. (interior and exterior rockwork), John and Emily Agnew (live exhibit dioramas)
**Fabricators:** Display Sales, Inc.; Precision Photo Laboratories, Inc.; Cobb Typesetting Co.

# Science of Sports

The idea behind the traveling exhibit that originated at the Columbus, Ohio, Center of Science and Industry (COSI) was ingenious, apt and simple: to use sports, with which most of us are familiar, to illustrate and teach scientific principles, which too many of us know too little about.

COSI had already been toying with the idea of an exhibit based on sports and science when they were asked by the Science Museum Exhibit Collaborative to prepare the first of what is to be a continuing series of traveling exhibits, originated and shared by the Collaborative's eight members. Besides COSI, the participating museums are: Museum of Science and Industry (Chicago), Science Museums of Charlotte (Charlotte, North Carolina), Franklin Institute Science Museum (Philadelphia), California Museum of Science and Industry (Los Angeles), Fort Worth Museum of Science and Industry (Fort Worth), Museum of Science (Boston), and Science Museum of Minnesota (St. Paul).

With Collaborative backing came a stipend of $250,000, which allowed COSI to expand the exhibit's scope greatly (they put in some $100,000 of their own money also) and a strict deadline only six months away.

Several COSI departments cooperated in developing the exhibit, but initially the designers (COSI's Exhibits Department) reached out beyond the museum. As they have done in the past, COSI set up a committee of prominent Columbus citizens with expertise in the subject at hand—in this case, sports and

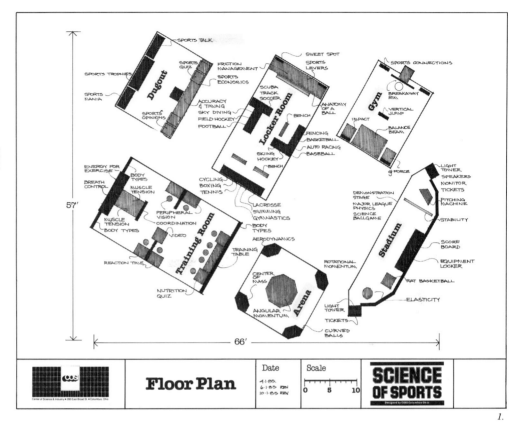

1.

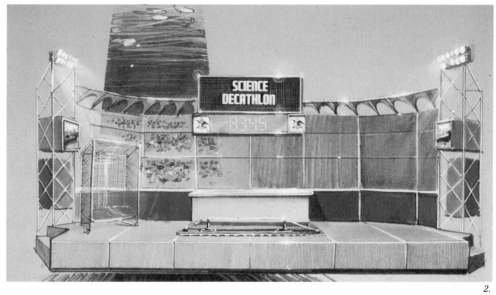

2.

1. Floor plan shows how six exhibit areas were clustered.
2. Color study for Stadium section.

science. Besides physicists, physicians and professors, there were a nutritionist, football coaches (Earle Bruce and Woody Hayes) and sportswriters. And, says Chuck O'Connor, who heads Exhibits and Planning at COSI, "about 12 committee members were really helpful, coming up with continuous ideas and suggestions."

Both COSI and the Collaborative wanted the exhibit to engage visitors as fully as possible, and to this end O'Connor tried to design an exhibit that would appeal to visitors through practically all of their senses and at the same time give them a lot to do, with many opportunities to participate.

As a result, there are physical things a visitor can do, such as jumping up onto a platform scale to register G forces, and removing pressure from a button at a given signal to register reaction time. (O'Connor is constantly alert to hard use given an exhibit that asks visitors to participate, and he designed the reaction-time display so that visitors *release* a button to signal a reaction instead of punching one.) And throughout the exhibit are a dozen computer terminals with modified keyboards from which visitors can elicit information or responses.

The designers planned the exhibit to fit into 4000 sq. ft., which is the space available for traveling exhibits at COSI, the smallest space on the Collaborative tour. In other installations, the exhibit can be spread out slightly by merely increasing the space between each of its six sections.

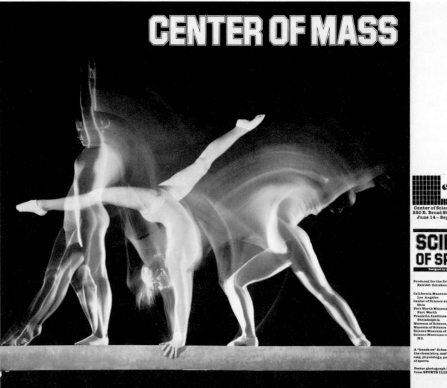

CENTER OF MASS

Center of Science and Industry
280 E. Broad St., Columbus, Ohio
June 14—September 2, 1984

SCIENCE OF SPORTS
Designed by COSI Columbus Ohio

Produced for the Science Museum
Exhibit Collaborative:

California Museum of Science and Industry,
Los Angeles
Center of Science and Industry, Columbus,
Ohio
Fort Worth Museum of Science and History,
Fort Worth
Franklin Institute Science Museum,
Philadelphia
Museum of Science, Boston
Museum of Science and Industry, Chicago
Science Museum of Minnesota, St. Paul
Science Museums of Charlotte, Charlotte,
N.C.

A "hands on" Science Exhibition exploring
the chemistry, mathematics, physics, anat-
omy, physiology, psychology, and sociology
of sports.

Poster photograph by Heinz Kluetmeier
from SPORTS ILLUSTRATED

3.

Each of these six sections is designed to simulate a place familiar in sports: Training Room, Arena, Stadium, Dugout, Locker Room and Gym. And within each area are exhibit units that seem appropriate for that type of space. For example, in the Training Room visitors can take a computer nutrition quiz, pushing a button to get questions on certain nutrition subjects; judge their reaction time; check peripheral vision, breath control, and muscle tension, and look at displays that show the ideal body types for various sports.

Of course, everything had to be designed to travel, and so

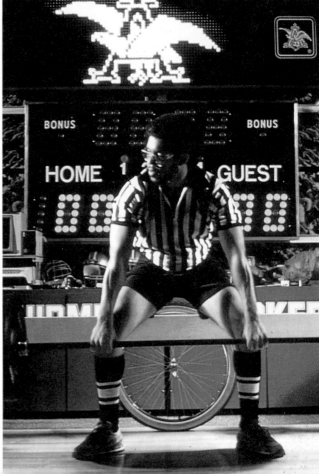

4.

floors, graphic panels and light grids with spotlights are all modular. Each panel knocks down into a 24″ square. And the gym floor is eight sections of the natural maple flooring used in basketball arenas.

Since some of the exhibit sites have low ceilings, the designers engineered a few of the taller components with a removable upper section.

The exhibit packs for travel in one and a half vans.

Live demonstrations take place in the Stadium section on a schedule that can be set up and varied by individual museums. COSI developed and wrote four 10-minute shows and hired a performer who travels with the exhibit. Sports music precedes each show and a question session follows.

"Sometimes it's safer and cheaper to put material into a live show than to build an exhibit unit to present it," says Chuck O'Connor. One thing the live demonstrator does is drop a frozen tennis ball to show that temperature determines how high a ball will bounce. Done somehow in a static display device, bouncing frozen and unfrozen tennis balls might erode an exhibit budget.

Sports sounds are part of the exhibit, too. One of the designers, who is a basketball enthusiast, a couple of local sportswriters and a local announcer put together a tape. It's a narration of a fabricated basketball game, which includes all the basketball slang they could think of. The tape plays continuously in the Dugout.

The designers created and the museum hands out some graphic materials, such as an activities kit that's meant to be taken back to the classroom for discussion or home for review. Kit brochures explain, for instance, the physics of Bernoulli's principle applied to a ball's flight. But the exhibit's real teaching comes from the computerized devices operated by visitors and from the dozens of photographs, some life-sized and hung separately, some smaller and grouped in collages (all taken by Sports Illustrated photographers).

Using lighting and color, the designers tried to reproduce the atmosphere of the particular sports areas. For instance, quartz lights in the Training Room create what they feel is an appropriately antiseptic atmosphere.

Obviously, the exhibit is fun and wherever it has appeared so far it has set museum attendance records.

5.

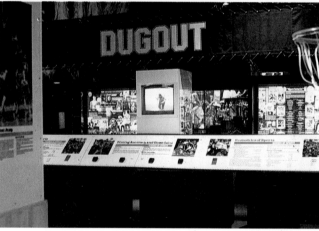

6.

**Client:** Science Museum Exhibit Collaborative
**Design firm:** Exhibits Dept., Center of Science and Industry, Columbus, OH
**Designers:** Chuck O'Connor (executive vice-president for exhibits and planning), Glen Gilbert, Matt Rothan
**Consultants:** 36-member Advisory Committee
**Fabricators:** COSI; Boss Display Fixtures; Chroma Studios; Wolf Metals; Mid Ohio Screen Print; Morrison Sign; Jerry Gibson

3. *Exhibition poster.*
4. *Demonstrator lifts weights in Stadium area.*
5. *Graphics in Gymnasium section.*
6. *Computerized devices in Dugout section.*

# General Foods Collection

On the 4th floor of the new General Foods headquarters building in Ryebrook, New York, are what the company calls "employee facilities." Among them—the barbershop, a cafeteria, a bank, and so on— is 4000 sq. ft. of space for a permanent exhibition of food-related objects and for changing exhibits on food-related themes.

Rudolph de Harak and Associates, of New York City, designed the exhibits with the aid of the building's architects, Kevin Roche John Dinkeloo Associates of Hamden, Connecticut, who collaborated on the exterior design of the exhibits' permanent display cases.

The two firms had worked together on the Egyptian collection at New York's Metropolitan Museum of Art, Roche Dinkeloo doing the exhibits and de Harak the graphics. And although their roles were different in the General Foods exhibit, it is not surprising that the work has the flavor of what they did for the Metropolitan. It has the same finely detailed feeling of elegance and permanence, and that is what the client wanted. But in the General Foods exhibit the client also wanted something to exhibit and de Harak and Associates took on the job of acquiring a collection of food-related objects and tools. De Harak did some preliminary research on what might be included and then hired Nancy Campbell as a full-time research consultant to make the final acquisitions.

There are 1000 objects in the show—baskets, plates, grinders, scrapers, graters, churns, cups, spoons, and so on, from many cultures and many historic eras, and with the completion of the exhibit, Nancy Campbell joined General Foods as curator of the collection. She was responsible for the concept behind four temporary exhibits designed by the de Harak group for General Foods in the year after the permanent collection opened.

To house these exhibits (permanent and changing), the corporation allowed space in a main gallery, opening off an elevator corridor, and in two corridors leading into the main gallery, about 4000 sq. ft. in all. The changing exhibits are in the two corridors and in the main gallery.

The main gallery holds objects in a long floor-to-ceiling display case that undulates 93' along one wall. Glass panels in 4'-by-8'-high sections that fit into floor and ceiling grooves front this case. Every so often, a door with a floor lock allows access to the displays, which are on platforms 1½' back from the glass, so that someone can get into the case to clean or change items.

Over the cases are light boxes with fronts that angle out from the glass to the ceiling.

Because these front panels are hinged and held shut by touch locks, one can reach into the light boxes to change a light bulb without disturbing the displays.

The gallery also holds two large island cases 18' by 6', one at either end of the gallery, lined up parallel to the room's central axis. Their design is similar to the wall cases, with overhead light boxes and locked doors for access. In the gallery's center are the eight pedestal-mounted vitrines, which hold changing-exhibit items. Plexiglass vitrines, 1½' square, fit into aluminum channels in the gray laminate-faced wooden pedestals and are held there by screws. Pads of fabric, painted wood or translucent glass slip over the pedestal tops. Some of these free-standing pedestals (and some of the pedestals in the wall cases) have lights which shine through translucent pads to backlight objects above. If

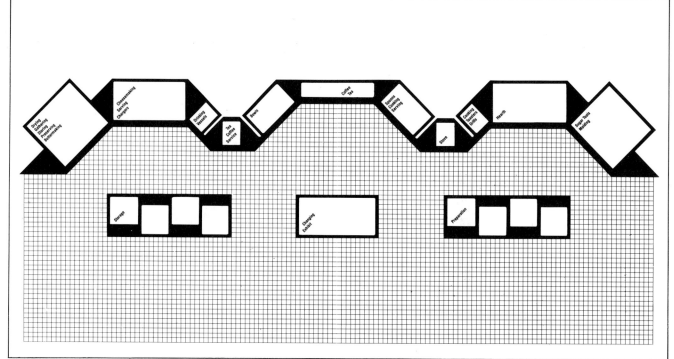

1.

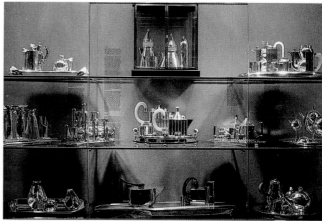

2.

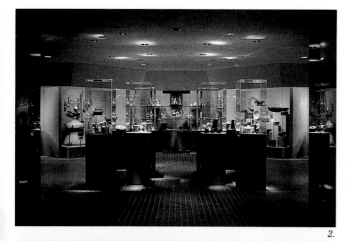

3.

4.

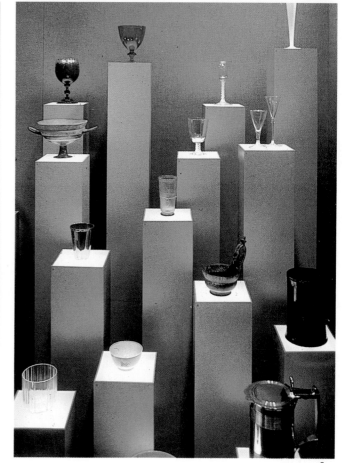

5.

1. *Floor plan of permanent exhibit at General Foods headquarters, with cases indicated by center rectangles in top and bottom row given over to temporary exhibits.*

2. *Six standing cases in foreground hold changing exhibit within the permanent exhibit hall.*

3. *This case, in back of free-standing cases (Fig. 2) also holds a temporary exhibit. Shown here are Alessi coffee and tea services.*

4. *Catalogues for temporary exhibits.*

5. *Drinking vessels each have separate pedestals.*

not backlighted, objects in the vitrines are lighted by down lights set in the ceiling's acoustic tiles.

Angling off either end of the permanent space are temporary exhibits in 20′-long, 8′-high wall cases mounted a couple of feet off the floor, on gliders in steel channels. Curved at top and bottom, the plexiglass cases bow out from the wall forming a 6½″ space in which to mount objects. Cases in 3′ sections slide into place.

Materials on the back walls of the wall cases change according to what objects are being displayed. Sometimes the back wall is fabric, sometimes painted or lacquered plywood. Colors in the changing exhibit corridors change to adapt to what's being exhibited. In the permanent gallery, colors are greens and a warm gray to go with the pervasive yellow green of the 2″ by 2″ ceramic floor tiles.

The designers silk-screened captions and text directly on the glass cases in Helvetica condensed typeface.

De Harak has a yearly contract with General Foods to design changing exhibits; the four done during the first year were "Food Tools as an Extension of the Hand," "History of the Cookbook," "Shaker Food Tools," and "Delft Porcelain." Each was installed in six to eight weeks.

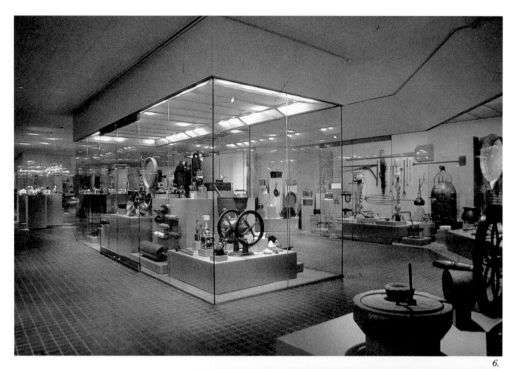

6.

6. *Permanent collection cases provide plenty of room for someone to enter for the purpose of cleaning and rearranging.*
7. *Detail from permanent exhibition model, bowls and goblets.*

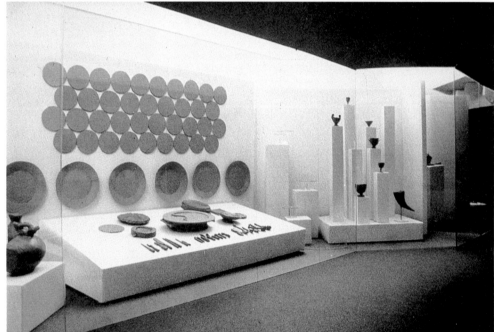

7.

**Client:** General Foods Corp. (Ryebrook, NY)
**Design firm:** Rudolph de Harak & Associates, Inc., New York City
**PERMANENT EXHIBIT**
**Designers:** John Branigan (project manager), Richard Poulin, Lai Hom, Margie Chin, Jim Dustin
**Consultants:** Nancy Campbell (curator), Howard Brandston Lighting Design, Kevin Roche John Dinkeloo Associates (architects)
**Fabricators:** Hamilton Displays, Rathe Productions
**CHANGING DISPLAY PROGRAM**
**Designers:** Richard Poulin (project director), Linda Kondo, Kirsten Steinorth, Todd Blank
**Consultants:** Nancy Campbell (curator), Howard Brandston Lighting Design
**Fabricators:** Howard Walode Associates, The Exhibit Co.

*8. Rolling pins and collanders in permanent collection.*
*9. A temporary exhibit of cookbooks.*
*0. Acquisitions concept presentation board.*

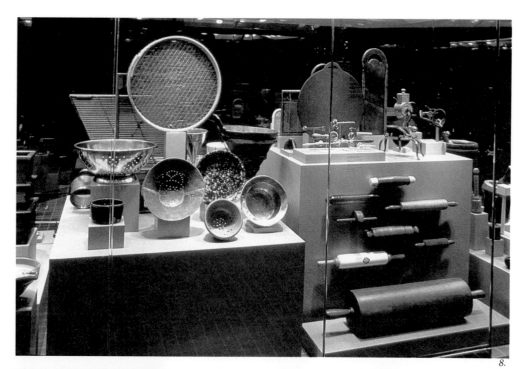

8.

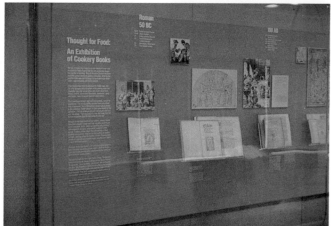

9.

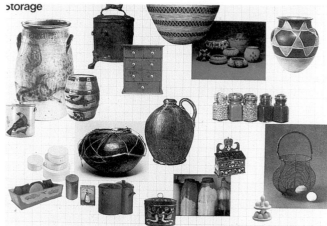

10.

# Ethospace

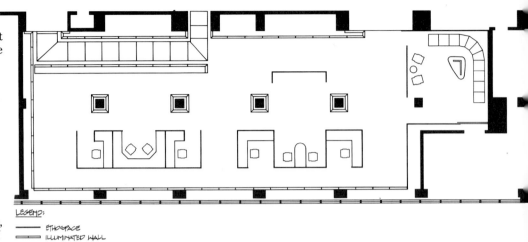

Ethospace is the most recent Herman Miller office system. It consists of tables, files, storage cabinets, work surfaces, walls, internal wiring, even a lamp, and it can be set up anywhere, without fastening it to anything but its own components for support. Built on a 17½" module, Ethospace's partitions stack to any height and can be easily juxtaposed in any configuration or width. But perhaps most importantly, its partition panels come in glass, fabric (opaque or semi-opaque), and vinyl, so that the quality of light in the workspace can vary considerably. Ethospace's designer, Bill Stumpf, feels strongly about light, and so for Ethospace's introduction to the trade, Donovan and Green, the New York design firm, created a setting with light in the Herman Miller New York City showroom.

Using theatrical scrim fabric stapled to 17½" modular wooden frames, Donovan and Green's Michael Donovan put together walls by stacking the frames and tacking them to the showroom's floor and ceiling. Every 36" within these frame and fabric walls, Donovan set a fluorescent fixture, modulating its light with a filter to give a daylight quality.

Donovan also put up his frame and fabric modules around the showroom's central pillars. "The problem," he says, "was to change the quality of the space entirely—to block out the showroom's walls and windows by creating a space within the space, built out 24" from the existing walls." The result was a glowing diaphanous box that had a sort of Japanese teahouse effect—as if a grid of

LEGEND:
⎯⎯ ETHOSPACE
═══ ILLUMINATED WALL

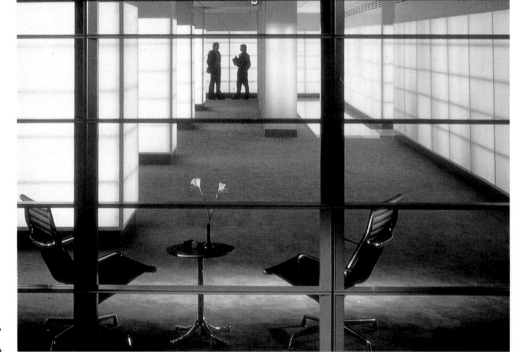

2.

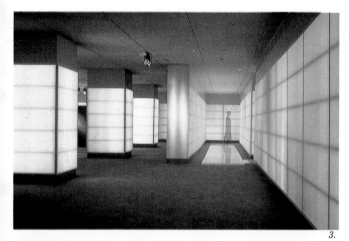

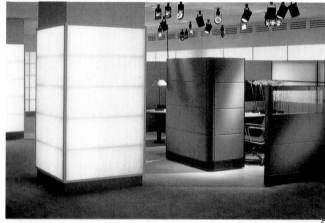

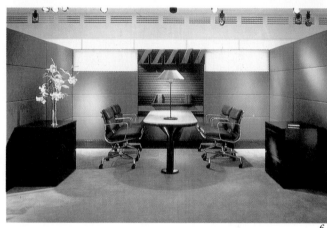

interiorly lighted tatami mats had been fastened to the walls.

A beige carpet covered the floor, but as visitors entered, through a glowing corridor walled with Donovan's scrim-covered frames, they walked on a hollow-cored walkway of fiberboard painted with Imron, a high-lacquer marine paint. The walkway echoed visitor's footsteps, and because visitors could see narrow strips of carpet on either side of the walkway, it seemed like a floating dock. Donovan feels this dock helped "sensitize the visitor to the environment and subtly helped prepare him for viewing the new product."

The glowing space housed Ethospace alone, no graphics, no type. "The space was serene," Donovan says, "even with a lot of people milling around in it."

**Client:** Herman Miller, Inc. (Holland, MI)
**Design firm:** Donovan and Green, Inc., New York, NY
**Designers:** Michael Donovan, Dana Christenson
**Consultant:** Richard Nelson (lighting)
**Fabricator:** Rathe Production, Inc.; Robert Rathe (partner-in-charge)

1. Floor plan.
2, 3. Herman Miller showroom walls and pillars glow with inner fluorescent light for Ethospace introduction.
4, 5, 6. Within the glowing walls, Herman Miller set up various configurations and combinations of Ethospace office system.

# Tower 75

In 1909, when the Metropolitan Life Insurance Company tower went up at 23rd Street and Madison Avenue in New York City, the company crowed proudly at what it had wrought. Not only was the tower, at 700 ft., the tallest occupied structure in the U.S. (it was to remain so for four years, until the construction of the Woolworth Building), but also its architects, Napoleon LeBrun & Sons, had used the building to experiment with what was a relatively novel construction technique—a steel interior frame clad in masonry (Tukahoe marble). Its style is that of the Italian Renaissance, modeled after the Campanile of St. Mark's Basilica in Venice. Four clock faces 26½′ in diameter span the 25th to the 27th floors. Its minute hands weigh half a ton. Its numerals are 4′ high and minute marks nearly 1′ in diameter.

An image of the tower became the Metropolitan Life logotype, and for 75 years the company archives gathered memorabilia about it and the company—models, drawings, commemorative spoons, pens and medals.

A good deal of this material went on display in a lobby exhibit marking the building's 75th anniversary. Designed by Greenboam & Casey Associates, the exhibit fit into a

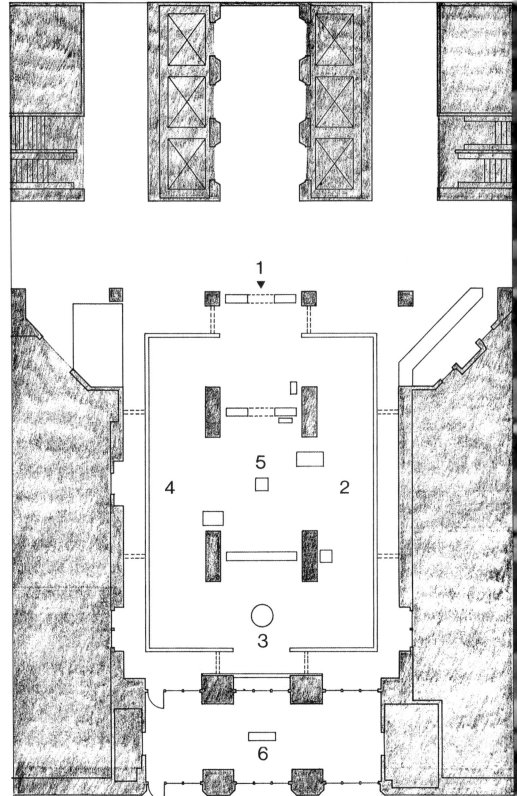

*1.*

LEGEND:
1. Cupola cut-out Entrance
2. Early History
3. Tower Architects
(Nathaniel LeBrun & Sons)
4. Tower Today
5. Models
6. Cupola cut-out

3760-sq.-ft. space in a little-used side lobby off the building's main entrance corridor.

The designers called in Tom Casey's brother, Daniel, a local architect, to help them create an exhibit space, and ended with a small museum space, a permanent gallery, which the company is reusing for other exhibits.

There were some house rules affecting the way the designers could handle their design. The Metropolitan Life lobby's walls and floor are clad in polished Italian marble, and nothing could be attached to them in any way that would leave a permanent scar. Fortunately, the ceiling is plaster, and Daniel Casey devised a system of 14' high, 4' wide sheet rock section walls that are bracketed, then bolted to the ceiling and held to the walls with double-faced tape. They painted these wall surfaces a specially ordered light gray.

Entrance to the exhibit was through a 15'-high cutout space, in one of the sheet rock walls, which followed the outline of the tower cupola. The actual portion cut out, a silhouette of the cupola, was set up just inside the building's main entrance, where it could be seen from the street. Silk-screened on it was the exhibit title—"Tower 75."

Flanking the exhibit entrance was a statement by Metropolitan Life's chairman, and on the other side a grouping of photographs of the tower in 1909. Metropolitan Life wanted half the exhibit to deal with the tower as it was and half with how it is today.

Photos by Norman McGrath.

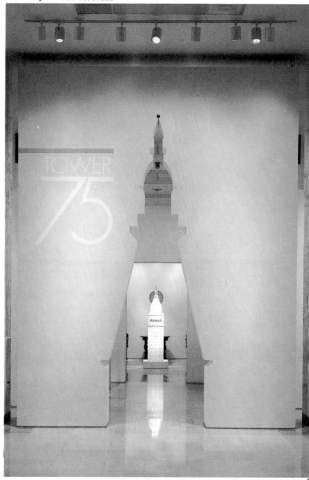

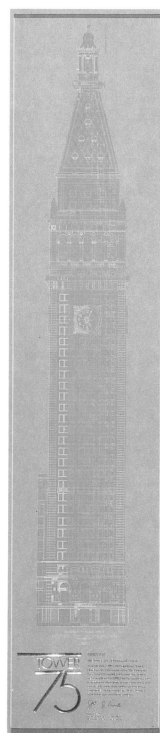

3.

1. Exhibit entrance sketch.
2. Metropolitan Life Tower's 75th anniversary poster.
3. Entrance to exhibit through Tower cut out of sheetrock.
4. Original drawing of Metropolitan Life Tower by architects Napoleon LeBrun & Sons.

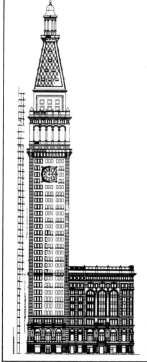

2.

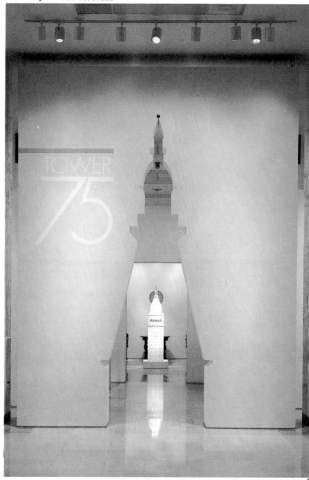

4.

Inside, the exhibit displayed photos, blueprints, and artifacts (such as board room tables and chairs designed by Napoleon LeBrun & Sons), mostly mounted on the exhibit walls, with several models of the tower positioned throughout the space on pedestals, some with acrylic vitrines. Perhaps the most striking model is a 6′ silver tower model with working chimes and clocks designed by Tiffany. The company had had two made and presented one to the architects. The other went into the company archives. Permanently mounted on a 6′, lead-filled wooden pedestal, the model was left uncovered, unprotected by a vitrine, so visitors could hear the chimes. However, to keep visitors from getting too close, the designers placed the model and its pedestal on a 4′-diameter, 8″-high circular wooden platform (painted gray).

They mounted flat items, such as blueprints and drawings, on display board, which, in turn, was mounted on plywood and framed in aluminum. A couple of quarter-scale 16′-high elevation

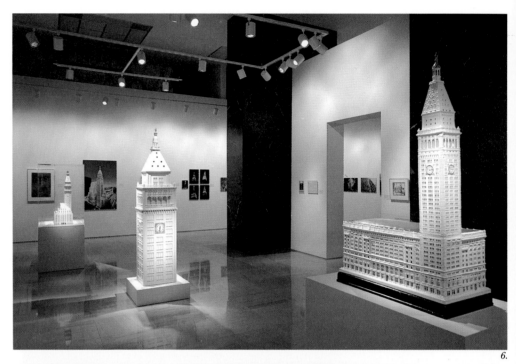

6.

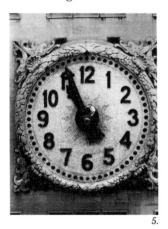

5.

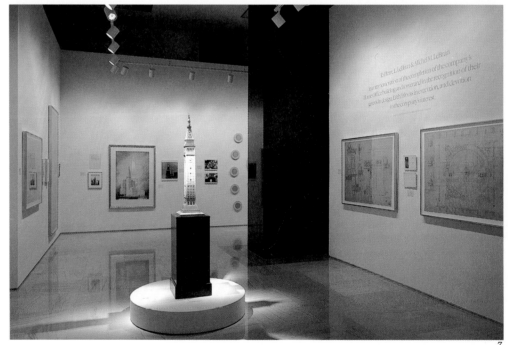

7.

drawings on fabric, mounted this way, were hung in the lobby outside the exhibit and are still there now, though the exhibit is gone.

Lighting came from a ceiling-mounted light grid with low-voltage spots that washed the walls and focused on specific items, throwing shadows on the floor. One of the exhibit's most striking features was the image of its tower models reflected in the highly polished marble floors. Outside light from 23rd Street was kept out by hanging opaque, white fabric screens from the ceiling.

The *Casebook* jurors praised the exhibit's simplicity. "The designer wisely didn't try to do too much," one juror said.

Captions and explanatory text were silk-screened in light blue on acrylic panels of various sizes and positioned throughout the exhibit to coincide with the scale and shapes of the items displayed, so that these panels became elements in the exhibit's pattern.

Greenboam & Casey specified Futura Light type for headlines and Garamond Book for text.

They created the exhibit and, with Daniel Casey, its gallery in eight weeks on a budget of $150,000, which did not include lighting or security.

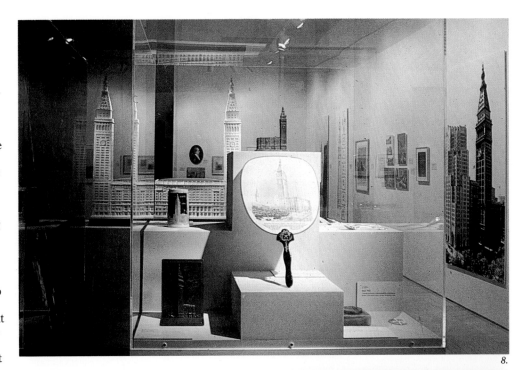

8.

9.

**Client:** Metropolitan Life Insurance Co. (New York City)
**Design firm:** Greenboam & Casey Associates, New York, NY, with Daniel T. Casey, architect
**Designers:** Robert Greenboam, Thomas Casey, Stephanie Fields, Michael Gibson, James Ho
**Consultants:** Andrew Dolkart (architectural historian), Robert Moulthrop (communication consultant)
**Project coordinator:** Charlotte Guarino (Metropolitan Life)
**Fabricators:** D. F. P. Construction (enclosure); Graphic Signage Systems (signing and graphics); APF Framing (framing, pedestals and cases); Characters, Inc. (typesetting); George Barnaik (installation); Rik Shaw Associates (photo enlargements)

5. One of four 26½'-diameter clock faces on facade of Metropolitan Life Tower. Note workman in center.
6. Models of Tower (tin model in foreground) in front of Tower history wall.
7. Tiffany model of Tower, surrounded by Tower blueprints, is identical to one originally presented to the architects on building's completion.
8. Memorabilia case.
9. Full-scale models of Tower clocks' numeral and minute marks.

# 2nd International Shoebox Sculpture Exhibition

None of the sculpture submitted for possible inclusion in this month-long exhibit at the University of Hawaii Art Gallery had dimensions larger than a standard-size shoebox. That was the rule. And following their stay in Hawaii, the 103 selected sculptures traveled to 10 other museums in the U.S. and Canada.

Tom Klobe, director of the University of Hawaii's Art Gallery, wanted to display all the works equally, not giving any one piece an advantage over any other, in an environment that would nevertheless have some variety and a life of its own.

His solution was a series of 13 L-shaped platforms, 2' wide in various lengths, each platform raised 35" off the gallery floor on three ceramic sewer pipes. Exhibit coordinator Sharon Tasaka, a graduate art student, found sewer pipes with a 14" diameter for $4 each at a "State surplus" store to match the diameter of the gallery's four supporting columns. (Four of the L-shaped platforms were supported at their central angle by the gallery's supporting columns, tying the columns in with the exhibit.) To further coordinate platforms, columns and supports, Klobe had them all painted white, and set low, white sculpture pedestals (3" high by 27½" by 17") on the platforms, one for each piece of sculpture. (He fastened sculpture meant to be wall-mounted to panels set vertically on the pedestals.) These were the same pedestals Klobe had used in the 1st International Shoebox Sculpture Exhibit four years earlier.

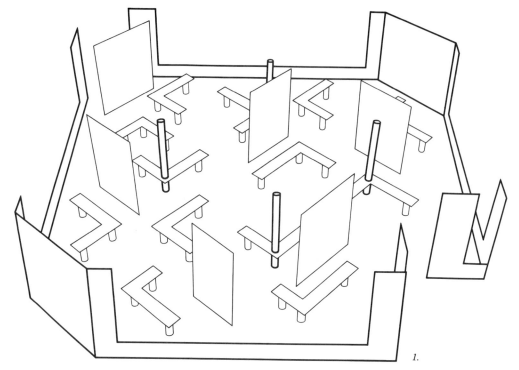

1.

Individual labels placed on both sides of the platforms in front of each pedestal were in 828 Bulletin typeface, typed on an Olympia word processor.

Six 14'-high, free-standing walls in various widths punctuated the exhibit, lending it color and giving it, in Klobe's words, a "contemporary accent." He painted each of these walls in one of five colors of equal value—lavender, pink, aqua, blue and yellow, and painted the wall ends a contrasting color.

Besides breaking up the space, these walls made it impossible for visitors to quickly take in the entire extent of the exhibit in the 4200-sq. ft. octagonal hall. The show title appeared as a graphic element in Times Roman typeface on one of the walls near the exhibit entrance.

The hall has surrounding floor-to-ceiling windows, but Klobe painted what solid wall surface there was around the windows a dark brown, thus tying it in with the ceiling (also dark brown) and with the floor's dark natural wood.

Finally, he lighted the sculpture platforms evenly from ceiling floodlights, giving all the sculpture equal light and focusing a lower intensity light on the colored walls.

In that context, each sculpture stood on its own, and the designers tried to heighten that individuality by placing each piece to contrast with its neighbors in texture, material and form.

The gallery had a month to install the exhibit, and Klobe started on it while still dismantling and packing the gallery's previous exhibit of

Greek and Russian icons (also selected for this *Casebook*; see page 44).

Since the gallery has no full-time employees, Klobe had to put the exhibit in place with the help of part-time student assistants and volunteers. He did it on a budget of $3925.

The *Casebook* jurors called the exhibit "elegant" and particularly praised the way the design gave equal play to each piece of sculpture.

**Client:** University of Hawaii Art Gallery (Honolulu)
**Sponsors:** National Endowment for the Arts; Contemporary Arts Center of Hawaii
**Designers:** Sharon Tasaka (exhibition coordinator), Tom Klobe (gallery director)
**Consultants:** Karen Thompson (associate gallery director), Mamoru Sato, Fred Roster (professors of sculpture); Cheryl Brzezinski, Brenda Iwai, Malcolm Mekaru (catalogue)

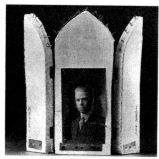

2.

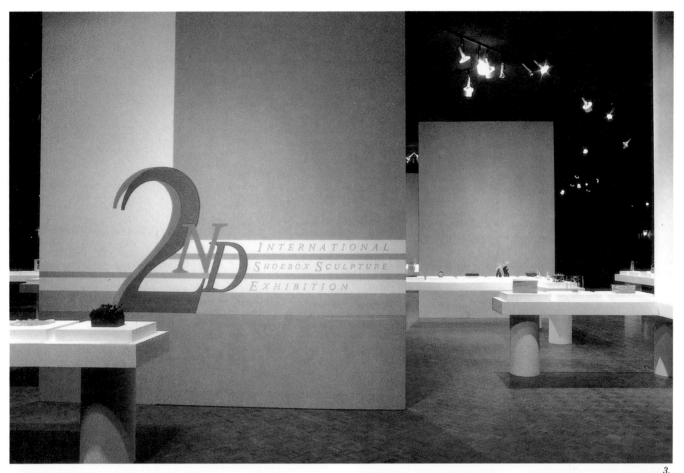

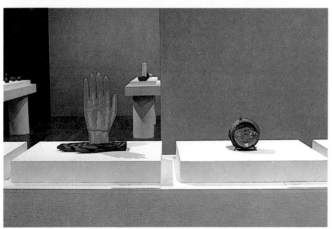

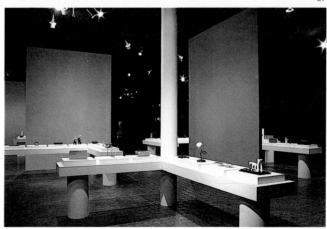

3.

4.

5.

1. Three-dimensional floor plan.
2. Back of a shoebox-sized triptych by sculptor William B. Renkl.
3. Graphics on free-standing walls were used to "break up" exhibit.
4. Each sculpture had its own pedestal.
5. Designers incorporated room's supporting columns into exhibit, using some of them to support center of L-shaped platforms.

# Greek and Russian Icons from the Charles Pankow Collection

The richness of the exhibit design matched the richness of the icons in this exhibition of 120 Greek and Russian icons of the 10th to 18th centuries. On display for five weeks in the University of Hawaii's Art Gallery, the icons came from the collection of Charles Pankow in San Francisco; gallery director Tom Klobe went to San Francisco to select specific items for the exhibit.

Icons, of course, are religious images—of Christ or the Virgin, of an apostle or a saint, or they may depict a scene from the Bible or from church history. Icons were hung in homes and in churches, and they were commonly hung over gates and doorways and were carried in processions. "The icon," writes Rex Wade, professor of Russian history at the University of Hawaii, in an essay in the exhibit catalogue, "was a window between the heavenly and earthly worlds through which the heavenly figures manifested themselves to mankind. . . . "

At the exhibit's entrance, visitors could watch a 10-minute slide show on the Byzantine and Russian cultures that used the icons.

Icons have a special interest for Tom Klobe. Besides being gallery director, he is associate professor of art history at the university, teaching courses in Early Christian and Medieval Art; and he has traveled in Italy and Turkey, researching and photographing Byzantine and Medieval art and architecture.

His exhibit design made the icons glow with light in an intimate Byzantine church-like setting.

The exhibit's plan was that of

a Greek cross. Four support columns in the space became anchors for arches designed by Klobe to cross the central area, then echo overhead down the alcove arms of the apses.

In the central area, Klobe mounted two large icons on two-legged metal stands. Other icons hung on the walls or on 2′ by 14′ plywood sections, which he hung out from the walls to give the image of columns in a Byzantine church. Sometimes he recessed icons in niches cut out of the plywood sections.

The gallery prides itself on holding costs down by reusing hardware and materials, and in the icon exhibit Klobe was able to use a gallery modular system of 4′-by-14′ and 2′-by-14′ plywood panels; and the ½″ plywood and ⅛″ Masonite purchased for the arches was subsequently reused. The arches ran between the existing gallery columns and specially constructed, square-sectioned columns, or between the walls and the 2′-by-14′ free-standing panels.

To help shape his vision of the exhibit, Klobe first built a model from which he drew a plan. Initially, he says, his concept was too monumental, too cathedral-like: "It lacked intimacy." And it left little for a visitor to discover, since the whole exhibit would have been visible from any point in the 4200-sq. ft. space. Klobe says, in this first plan, he did what he dislikes doing—create a space, then force exhibit items to conform to it. His second plan grew out of an attempt to create individual spaces for each item. "In planning an exhibition," he says, "I feel it's important that every object

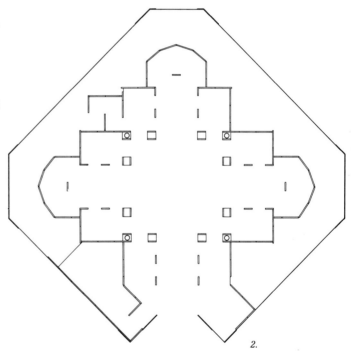

1.

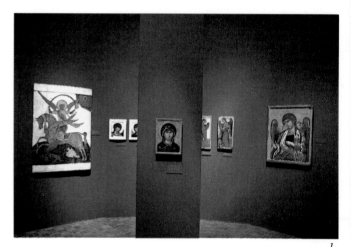

2.

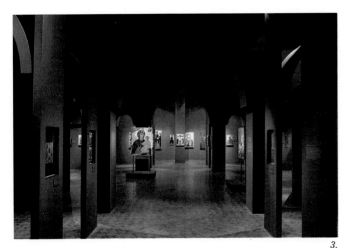

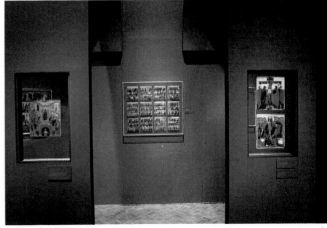

3.

4.

have a special space created for it."

The second plan, more intimate, was also more akin to a Byzantine church. Its central crossing was 22' square. Apses were 22' deep, and alcove arches were about 11' above the floor.

Throughout the gallery, Klobe painted the walls and arches a deep burgundy, selected to be a rich, dark background for the icons' brilliant colors and to blend into the ceiling's dark brown. By bouncing light from carefully positioned spotlights off each icon, he highlighted their golds and reds, making, in fact, each icon color stand out. Because the icon colors were so brilliant, the light made them seem to glow with an inner intensity, as if they really were windows between heaven and earth.

Klobe silk-screened text in a warm, gray-green Novarese typeface directly onto the walls. And he painted the wall bracket supports on which the plywood and Masonite arches rested a charcoal green.

Klobe's biggest problem was

time. Because of other exhibits in the space, he had only two weeks to install his icons and their setting, and he had no full-time labor to help him. His solution was to prefabricate the alcove arches on weekends during the month before the installation began and to start work on the installation while part of the gallery was still being used.

For labor he relied entirely on part-time student assistants and volunteers.

Budget for the exhibit design was $6100, not including audio-visual equipment.

This exhibit became the basis for a documentary video that showed on local Hawaiian television. The half-hour video follows the exhibit design through planning and installation to the opening reception; and in it, the designer, planners, student assistants, volunteers, critics and the public discuss and react to the exhibit.

The *Casebook* jurors especially praised the way the exhibit's color and structure reflected the content.

**Client:** University of Hawaii Art Gallery (Honolulu)
**Sponsors:** Hawaii State Foundation on Culture and the Arts; Charles Pankow & Van Doren Associates
**Designer:** Tom Klobe (gallery director)
**Consultants:** Karen Thompson, Heide Van Doren Betz (curator, Pankow Collection); Rex Wade (history); Allen Hori (graphics and catalogue design); Patricia Hayashi, Sam Kim, Mark Fontaine, Patty O'Neal (audio-visual presentation)
**Fabricators:** Cynthia Tsukahara, Scott Tome, Dennis Bader, Dave Beal, Pui Har Lau, Chrys Cundiff (student gallery assistants); Mark Fontaine, Stephan Doi, Rey Tesoro, Sharon Tasaka, Grace Murakami, students in Art 360 "Exhibition Design and Gallery Management" (volunteers)

1. Icons hang on deep burgundy walls.
2. Floor plan in shape of Greek cross.
3. Free-standing panels and Masonite arches form church-like setting.
4. Some icons inset into free-standing panels.
5. Archangel Gabriel tells Mary of impending birth in 15th-century Russian icon from Novgorod. Used on cover of exhibit catalogue.

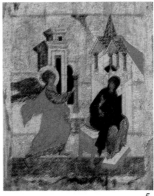

5.

# Heard Museum

Phoenix's Heard Museum now has a new hall for its permanent collection of southwestern U. S. Indian art and artifacts. More than that, all the museum's exhibit space and exhibits have an elegant new look.

A two-million-dollar building program, completed in 1984, roughly doubled the museum's space from 39,000 sq. ft. to 77,000 sq. ft.; and while much of that space went to offices, sales shops and the library, 11,000 sq. ft. went to galleries, increasing the museum's exhibit space to 33,000 sq. ft. One-third of this exhibit space is for the permanent collection, one-third for short-term exhibits (from three to six months), and one-third for longer-term exhibits of from six months to three years.

Though the building program adhered exactly to the original museum's Spanish architectural style—columns, arches, courtyards and red tile roofs—the exhibit designers created crisp, finely detailed, contemporary displays that let the museum's collections of African, Oceanic and southwestern U. S. art and artifacts set the color, texture and mood of the interior exhibit spaces. Moreover, Patrick Neary, who joined the museum in 1975 and who heads its Design Department, has finally been able to give the exhibit spaces a cohesive look.

Discussed here are the Heard's Great Hall for its permanent collection of southwestern U. S. art and artifacts and three temporary shows, all cited by the *Casebook* jury as examples of the Heard's uniformly good exhibit design.

1.

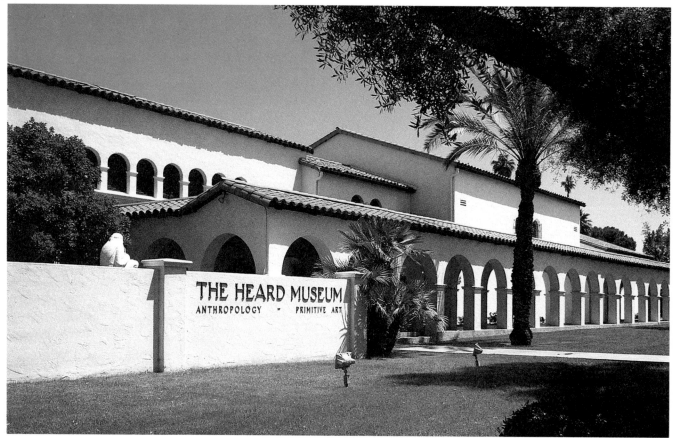

2.

3.

1. *Heard Museum logo.*
2, 3. *Views of Heard Museum.*
4. *Allan Houser sculpture ("Prayer Song") in Heard garden.*

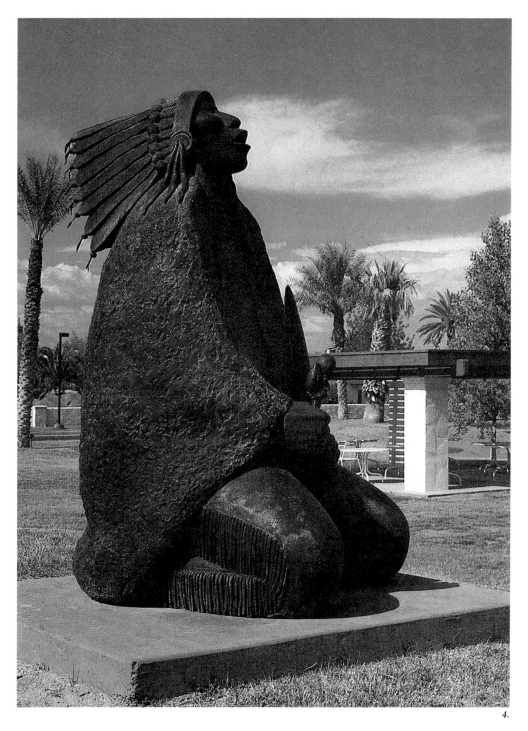

4.

## Native Peoples of the Southwest:
### The Permanent Collection of the Heard Museum

The Heard Museum's permanent collection has 12,000 sq. ft. of space to itself, made up of 8000 sq. ft. in a new addition and 4000 sq. ft. of old space (mostly from a former gift shop). Design director Neary gave the space and the permanent exhibit a handsome, homogeneous look in two years on a budget of $1,500,000.

The task was formidable. And it was obvious when the museum first discussed the problem that Neary and his department would need additional help to complete the program on schedule. Instead of hiring more staff, only to dismiss them once the program was completed, Neary approached independent design firms. The choice was New York City's Ralph Appelbaum Associates, who had considerable experience working in the Southwest with southwestern artifacts and art. They also were agreeable to Neary's working with them as design director.

While design went on, Neary would spend long stretches in New York—four to six weeks at a time—linked to Phoenix by computer.

Complicating the design process was the need to make regular reports to the museum board for approval. Every eight to ten weeks the designers would stop, review what they had done, and with either sketches or models make a presentation to a four- or five-member board committee, which would report to the full board.

In addition, Neary spent six months on the road, visiting other museums in Vancouver and across the U.S., asking about their design problems, hoping he could avoid them.

As a result, wall cases in the Heard's permanent gallery have interior walkways 1½′ wide in front of the displays—wide enough so that maintenance and curatorial personnel can get into the cases without dismantling them. Also, each case has an exterior overhead lightbox, so that bulbs can be changed from outside. Light shines from low-voltage, dimmer-controlled spots through the light boxes' glass floors, which are covered with semi-opaque film to cut glare and keep visitors from seeing the lights themselves.

Geography helped organize the exhibit space. Most of the artifacts had come from one of three southwestern regions — the Sonoran desert, uplands of Arizona and New Mexico, or the Colorado plateau—and so the permanent collection is displayed in these groupings.

But there is more to the exhibit than artifacts. "We wanted to design an exhibit space that would place the artifacts in their proper cultural context, while presenting them as beautiful works of art," says Pat Neary. To this end, the designers built into the exhibit four large architectural elements with rough edges and surfaces that both contrast with and complement the finely detailed, smoothly finished artifacts. These tactile structures—a hogan, a Hopi corn room, a Hohokam pithouse floor, and an Apache gowa were put together in the exhibit hall

1.

2.

1. Permanent collection floor plan.
2. Preliminary study, Kachina doll collection.
3. Wall graphic panel.
4. Sonoran desert photomurals.

by Native Americans.

Visitors move through the exhibit space on a course that meanders past cases and structures. Sometimes the course is elevated slightly to let viewers look down into and through the exhibit.

Visitors enter past a small, open audio-visual theater where they can sit and watch a three-screen slide show, "The People and the Land," in which voices of southwestern people give their feelings about the land and their way of life, as images of faces and landscapes appear on three 3′-by-4′ screens. The screens are elevated above cabinets fronted with a glossy Formica laminate which house audio-visual equipment for special showings. At either side of these cabinets are glass cases containing Native American artifacts. During the slide show, the lights playing on these cases dim or brighten, making the area into a small sound-and-light show.

Behind the three slide screens, rising from the floor to a lowered ceiling, is a curved, 22′ photomural of the American Southwest.

Beyond the wall mural, visitors enter what the museum calls the Great Hall, the exhibit proper. By using lights and colors, Neary and his designers lure visitors clockwise through the exhibit (rather than letting them move counterclockwise into a Katchina doll display, which is the exhibit's final event).

First, visitors pass a wall-mounted timeline showing how, where and when the ancient peoples of the Southwest appeared and adjusted to the region. Here and throughout

the exhibit, the designers use Baker Signet as the typeface for all headings and subheadings. For regular text and labels, they use Garamond Book, which works well with Baker Signet and is easy to read in all the sizes specified. Within the cases, a good deal of the type is on ½″ glass panels, cleated to the cases' floor then rising through slits in the glass at the bottom of the light boxes overhead to be fastened to ceiling tracks.

From the timeline, visitors walk up a slight incline to a 12′-by-15′ viewing platform area, raised some 14″ above the main gallery floor, from which one can see through most of the exhibit. Sunken into this area is a 6′-square relief map of the Southwest, formed by 11 cutout, spray-lacquered, high-density particle-board overlays. Light shines onto the map from fixtures behind a ½″ lip around the sunken area's periphery.

To keep visitors from falling into the map pit, the opening is protected by a 36″-high wall of

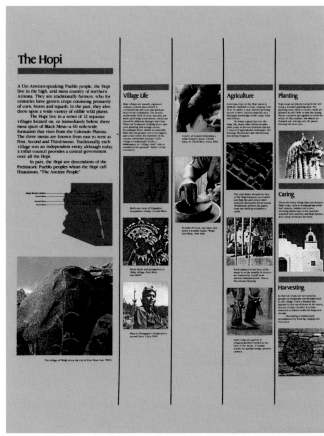

3.

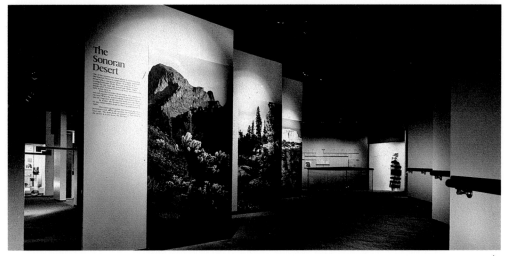

4.

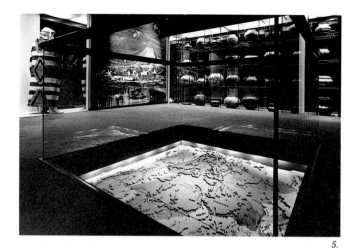

5.

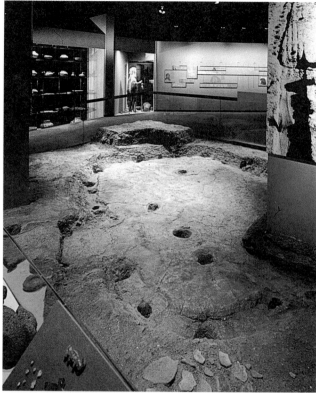

6.

¾"-thick glass panels, inserted into floor grooves and topped by a narrow black anodized railing.

The designers meant this area as one from which visitors can pause and get their bearings. They can look down onto the pithouse floor, for instance, which is a reconstruction of a Hohokam pithouse floor as it would appear after an archeological excavation. (In fact, an impression of an excavated pithouse floor about to be obliterated by a freeway in downtown Phoenix was actually moved to the Heard and set into the permanent gallery floor.) Visitors can also look from here through the Hopi corn room and through glass-walled cases into other sections of the exhibit.

Descending from the viewing platform, one moves through the exhibit, past wall cases and architectural structures. Neary wanted to carry his floor surfaces, carpet or wood planks, right into the wall cases, but the maintenance staff thought those surfaces would be hard to clean in the crowded cases. So the designers raised the cases 3" off the gallery floor and supplied each with a floor covering— sand, chopped shale, fiberglass-impregnated dirt—that suits the artifacts being displayed

Manikins display clothing, blankets and jewelry. Neary hadn't been pleased with manikins he'd purchased for previous exhibits, so for this one he cast his own. He persuaded Native American employees of the museum to have casts made of their faces and hands and then had manikins made up using these casts.

Wall colors and colors in the cases differ in different sections—gray and mauve in the introductory areas, earth and sand tones in the desert displays, muted greens and gray for the uplands, and for the Colorado plateau, shades of violet, plum and mauve.

Floor surfaces vary, too. Mostly, visitors walk on a gray carpet, but in the uplands section, the designers switched to wooden floor planking.

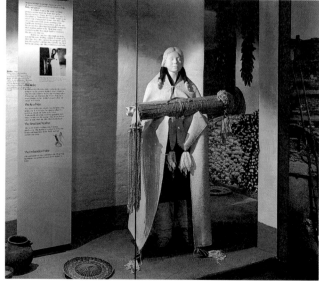

7.

Neary speaks of the reaction to the permanent exhibit as "overwhelming." Native Americans especially, he says, seem grateful for the time and care the institution took to present their culture in such a beautifully appropriate environment.

**Client:** Heard Museum (Phoenix); Michael J. Fox, chief executive officer
**Design firm:** Heard Museum Design Dept./Ralph Appelbaum Associates, Inc.
**Designers:** Patrick M. Neary (project design director/designer); Lisa MacCullum (graphics/mechanical production); Robert G. Breunig (project director/principal scriptwriter); Diana Pardue, Ann Marshall, Allyson Remz (scriptwriters)
**Consultants:** Ralph Appelbaum Associates, Inc.: Ralph Appelbaum, Gloria Caprio, Stephen Schlott, Scott Simeral (designers); Cheryl Filsinger (editor); Francis O'Shea (project administrator); Ralph Appelbaum, Robert Breunig (audio-visual concept); Harvey Lloyd Productions for Image Makers: Harvey Lloyd, Stephen Trumble, Bonnie Durcance (audio-visual program); Southwest Audio (technical services); a national advisory board, along with 32 anthropological consultants and educators (all material pertinent to Native Americans was reviewed by a tribal designate under the direction of Dr. Robert Breunig)
**Fabricators:** Heard Museum Building Dept.: Anthony Fleming, David Grove; Kitchell CEM (project construction management); Harlan Wilson Construction; Color House, Inc.; Decorative Design Associates; PML Services, Inc.; Design Origins

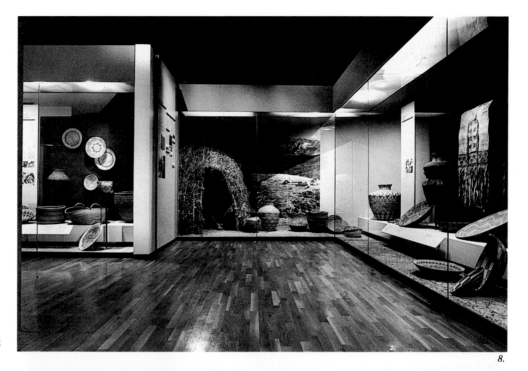

8.

*5. Floor graphic: Colorado plateau relief map.*
*6. Re-creation of a Hohokam pithouse floor.*
*7. Manikin heads were cast from Native American museum employees.*
*8. Apache gowa in wall case.*
*9. Hogan and Navajo textiles give collection texture and color.*

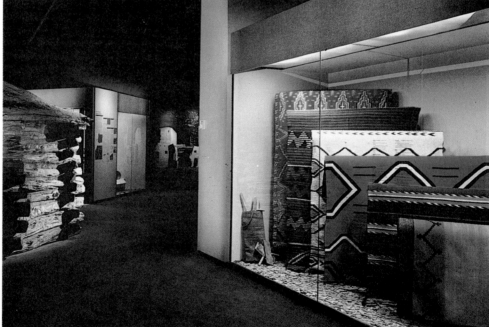

9.

## Mimbres Pottery: Ancient Art of the American Southwest

Phoenix's Heard Museum was a logical first stop for this traveling exhibit of Mimbres pottery—pottery fashioned by prehistoric southwestern American pueblo-dwellers. The exhibit originated in New York City, where the American Federation of the Arts put it together, complete with graphic panels, and it ran for two months at the Heard. It was the first exhibit to open there after completion of the building program.

Patrick Neary designed the show installation quickly, in one-and-a-half weeks, and in nine weeks had it in place in 2000 sq. ft. of gallery space that the Heard planned to use from then on for temporary exhibits. The show's pottery was mostly bowls, 125 ancient, fragile bowls, and Neary's design enabled the visitor to see almost all of them at once from anywhere in the gallery.

Wall cases zig-zagged down the perimeter walls, angled into

1.

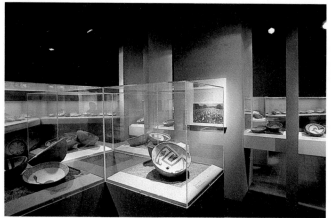

2.

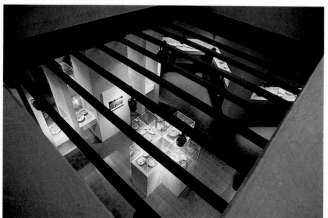

3.

the space and staggered, so that one always had a view of the continuing exhibit. Each of these cases was 10′ long with as many as 10 or 12 pottery items in a case. A series of free-standing walls lined up like soldiers marched down the room's central axis. These thin, sheetrock walls, 6″ by 3′ by 10′ high, presented their 6″ edges to the front of the room, and each platoon of walls supported four 2′-by-2′ clear display cases that seemed to float between the walls 40″ off the floor. The museum already had the 2′-by-2′ Lucite cases. "We had them and wanted to use them," Neary says. So he left ⅛″ space between the walls and each case; once the pottery was in place, the case covers could be slipped over it very carefully.

Neary devised a color scheme of soft greens and grays to echo the colors of the regions from which the pottery originally came. For instance, the perimeter walls were painted in various shades of muted green and gray. Case interiors were off-white and taupe.

To position the fragile, prehistoric bowls within the cases so that their interior decoration would be visible, Neary tilted each forward on a plexiglass ring-stand, and covered the bottom of the stand, and indeed the bottom of each case, with soft brown-green Vermiculite, which would not mar the delicate bowls.

This gallery has a 12′-by-12′ ceiling hole to tie it visually with the gallery above, and part of the ceiling light grid straddles this hole. The exhibit's low-voltage spotlights, which played on the pottery, were plugged

into light boxes mounted on the grid.

While it held the Mimbres pottery, the exhibit space also served another purpose. The Heard used it to test display systems for the new gallery housing the museum's permanent southwestern collections.

What pleased Neary most about the Mimbres pottery exhibit was that he was able to transform a large gallery into intimate spaces for viewing small-scale objects.

He did it on an exhibit budget of $7500.

**Client:** Heard Museum (Phoenix); Michael J. Fox, chief executive officer
**Design firm:** Heard Museum Design Dept.
**Sponsor and originating organization:** American Federation of the Arts, New York, NY
**Designers:** Patrick M. Neary (designer/design director); Lisa MacCullum (graphic designer)
**Curator:** Ann Marshall
**Fabricator:** Heard Museum Building Dept.: Anthony Fleming

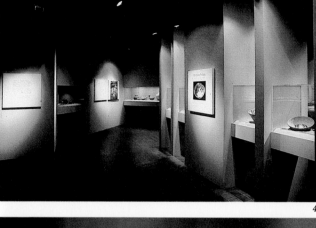
4.

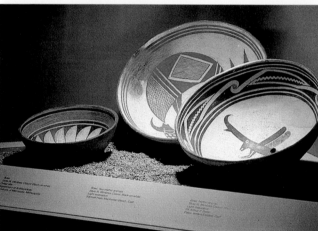
5.

1. *Mimbres bowl design.*
2. *Central-axis cases with wall cases in background.*
3. *View of Mimbres show from upper gallery.*
4. *Thin free-standing walls support display platforms.*
5. *Mimbres bowls canted forward on plexiglass ring stands.*
6. *Pictograph from Mimbres pottery.*

## Houser & Haozous: A Sculptural Retrospective

When the Heard completed its building program, what had once been an auditorium became space for temporary exhibits; and Patrick Neary redesigned the space so that no residue of its former identity remained. Among other things, he dropped the ceiling at the temporary gallery's entrance so that visitors enter through intimately scaled space, which immediately opens to 3000 sq. ft. of exhibit space beneath a 22′ ceiling.

The Heard's first exhibit in this new gallery was contemporary art by two Native Americans, father-and-son Apache sculptors Allan Houser and Robert Haozous. And in designing the exhibit, Neary created intimate spaces for smaller sculptural pieces by dropping ceilings in several areas of the room.

He built pedestals in scale to each piece, and since much of the sculpture was life-size and heavy enough to discourage theft, Neary left it unprotected on the pedestals. Besides, Houser and Haozous wanted their work to be touched. They had fashioned it from marble, alabaster, slate, steel, wood, bronze, and limestone, and they wanted visitors to experience its textures and forms by running their hands over it.

Neary worked closely with the sculptors, asking how they wanted each piece to be viewed, from what angle and height, in what light, and he placed them accordingly.

Each large piece had its own platform, pedestal or wall niche, although sometimes two or more pedestals were on one platform. Wall cases protected the smaller pieces behind glass.

Neary designed his spray-lacquered sheetrock walls and ceilings to give constant vistas of the larger works, and set up his wall cases so that visitors could see through them.

Graphics were minimal. Two graphic panels (24″ by 36″) showed the artists and held brief biographies in Oliver typeface.

Pedestals were the same spray-lacquered colors as the walls: rose, beige and gray, chosen to complement the sculpture's marble, alabaster and slate.

Even the exhibit title was sculptural, or at least three-dimensional. The letters were cut out in ½″ plywood, glued to a wall by the entrance and spray-lacquered in the wall's color: beige.

Budget for the exhibition was $9000, and the museum completed its design and installation in eight months.

**Client:** Heard Museum (Phoenix); Michael J. Fox, chief executive officer
**Design firm:** Heard Museum Design Dept.
**Designers:** Patrick M. Neary (designer/design director); Lisa MacCullum (graphic designer)
**Fabricator:** Heard Museum Building Dept.: Anthony Fleming

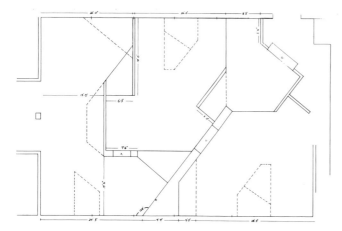

1.

2.

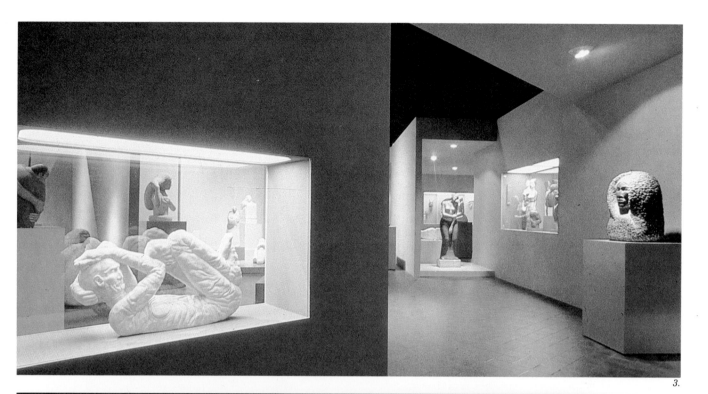

3.

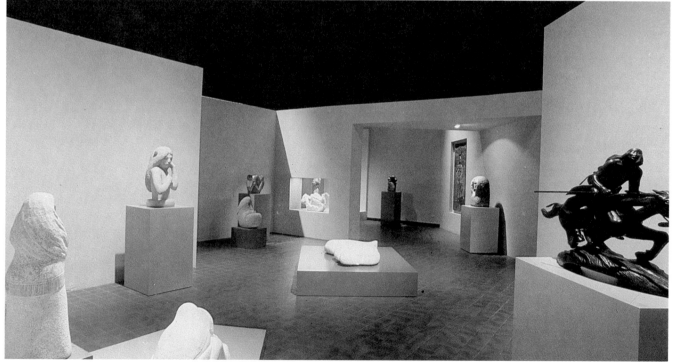

4.

1. Floor plan.
2. Painted limestone sculpture by Robert Haozous.
3, 4. Each sculpture has its own space, height and light.

## Animal, Bird & Myth in African Art

Mounted in a gallery transformed by the Heard's expansion into new exhibit space, and drawn from the museum's collection of African art, this exhibit ran for six months. Patrick Neary designed the exhibit immediately after the opening of the Heard's new exhibit hall for its permanent southwestern collections, and he gave the two spaces a family look.

Although the 3600-sq. ft. gallery has only one entrance and one exit, it has a 12'-square hole in the center of its floor, through which you can see the gallery directly below. Neary designed sheetrock walls for two sides of this see-through hole, giving the walls a squared U-shape, with the sides of the U reaching to the ceiling and the middle of the U open, so that visitors can see through to the exhibit beyond. He left the hole's other two sides protected only by a wrought-iron railing already in place there. The hole itself is latticed with beams, which support track lighting for the gallery below.

By putting his U-shaped walls on two sides of the hole, Neary at once both shut it out and tied it in with the upper exhibit hall. He repeated the U-shaped walls at four other positions in the hall, projecting them out into the hall from the side walls, forming what he calls four "pods." Each of the pods became the setting for items from a particular African geographical area.

For an introductory area, Neary designed 3'-by-3' recessed wall cases, with black interior walls. A recessed piece of glass fronts each case. The glass seems to rise from the top of a three-dimensional graphic wedge, set at each case's lower front edge. Because these wedges are in front of the glass, they can be removed from their dowel mountings and taken upstairs for silk-screening without disturbing the case interiors.

Neary positioned and lighted all the show's artifacts to present them as individual sculptural works of art. Since they were all of wood—masks, headdresses, reliquary figures, containers, combs and walking sticks—he found that by lighting them precisely with low-voltage pin spots against the black case-walls, he could heighten the various colors of the wood.

Besides the introductory wall cases, there were four free-standing cases with bases sloped at a 45-degree angle to match that of the graphic wedges; and there were 4'-by-4' cases, which flanked four open-sided low platforms where Neary positioned large pieces behind the same sort of low, black-anodized railing and glass panels that he had designed for portions of the Heard's permanent collection. If someone reached across the railings into the low platform space, a photo-cell alarm went off.

All the cases throughout the 40'-by-90' gallery had removable pieces of fabric

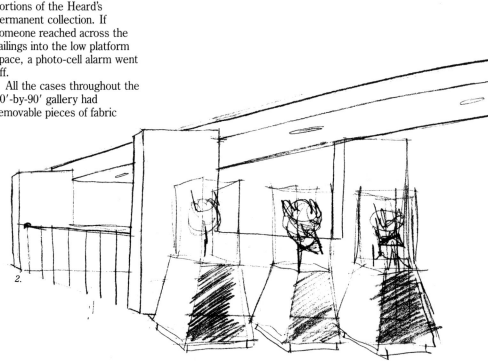

1.

2.

1. Scale model.
2. Preliminary study.
3. Wall cases in introductory area. Overhead is dropped lattice-work ceiling.
4. Cut-out walls partition space but let visitors see through to rest of exhibit.

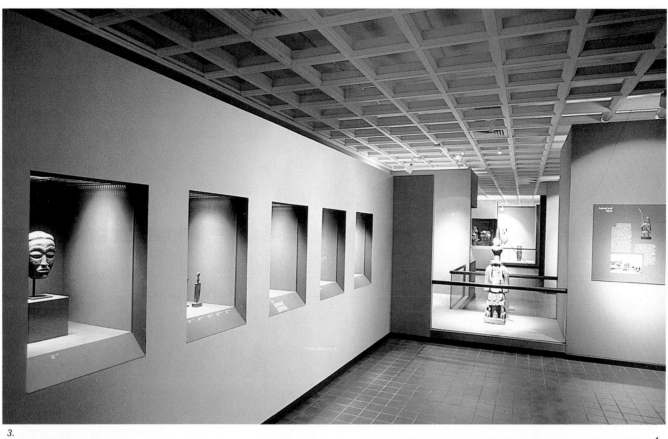

3.

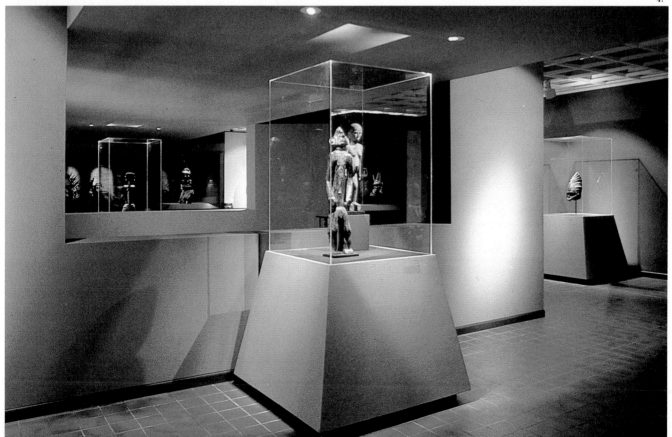

4.

5.

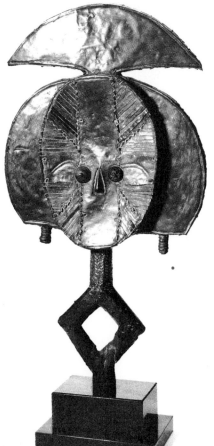

6.

beneath the sculpture they held. Neary varied the fabric colors from purple in the introductory cases, to cranberry, to teal blue, and he spray-lacquered the graphic wedges to match the fabric color. Exhibit walls were purple, light and dark gray.

Overhead, an open, wooden lattice-work ceiling dropped over the center of the gallery, running its entire 90′ length but only 12′ wide. Its grid was slightly larger than that of the floor's red quarry tile.

The designers specified Times Roman as the typeface for all graphic panels and individual labels. And they used it, too, for the exhibit title, which they had gold-leafed on the purple entry wall.

This entrance label set the dramatic tone Neary wanted for the exhibit, and he continued the drama with color and light that highlighted the African pieces, which, of course, were the exhibit's real drama.

Neary designed the modular exhibit system on a budget of $5000 over a period of a year.

Shortly after "Animal, Bird & Myth" closed, the designers adapted the space to a new show without "a total reconfiguration of the room," which, of course, was one of the main goals in creating the temporary exhibit space.

**Client:** Heard Museum (Phoenix); Michael J. Fox, chief executive officer
**Design firm:** Heard Museum Design Dept.
**Designers:** Patrick M. Neary (designer/design director); Lisa MacCullum (graphic designer)
**Fabricator:** Heard Museum Building Dept.: Anthony Fleming, David Grove

5. *Wooden porcupine headdress from Nigeria on purple fabric.*
6. *Reliquary figure from Gabon: wood with metal strips.*
7. *Pictograph.*

7.

# The Black Olympians: 1904-1984

Opening in time for the 1984 Summer Olympics in Los Angeles, "The Black Olympians" was the first exhibit mounted by the newly-formed California Afro-American Museum. And although the design and installation suffered through all the inevitable crises, delays and mistakes one would expect from a fledgling institution, the final result was so striking—so moving—that the museum extended the exhibit's stay a year beyond the originally planned two months. (It was later shown at the Chicago Museum of Science and Industry during February 1986 as part of that museum's . Black Creativity Month.)

Arranged around a theme that meshed American black history with the achievements of black Olympic athletes, the exhibit snaked along both sides of a four-lane running track of the same color (red), lane width and surface as that used in Olympic stadiums. Exhibit displays opened off the track, set back from it within carpeted areas behind walk-in openings in aqua-colored, sports-stadium guard rails.

The *Casebook* jurors praised the way the track gave the exhibit a central focus, noting that, as one walked through, the track held the exhibit together. Visitors liked the track, too. Kids ran on it,

although that was not the point. Indeed, the museum guards discouraged running. "There's a lot said about getting people to participate in exhibits," says Dextra Frankel with a laugh. "Well, we had participation!" Frankel is a partner in LAX Studios in Laguna Beach, California, the exhibit's designers.

The LAX designers further enhanced the feeling of a stadium by having the track slope gently up for its first 20″ and gently down for its last 20″. "We elevated 4000 sq. ft. of exhibit area," says Tom Hartman, the other LAX partner. They achieved this elevation by having a truss

manufacturer mass-produce a framework of 2x4's overlaid by flooring of ⅜″ plywood. Then they positioned 14′-high, 18½″-diameter Sonotubes as columns along the track's perimeter and used them to support a 5′6″-high graphics banner that carried the names of American Olympic medalists (in 2″-high silver vinyl Helvetica type) through the exhibit above the track. The banner was of Hexel, a cardboard core with laminated paper on one side. To increase the banner's stiffness, the designers laminated paper to its other side, and supported the banner by fitting it into slots at the top of the Sonotube columns.

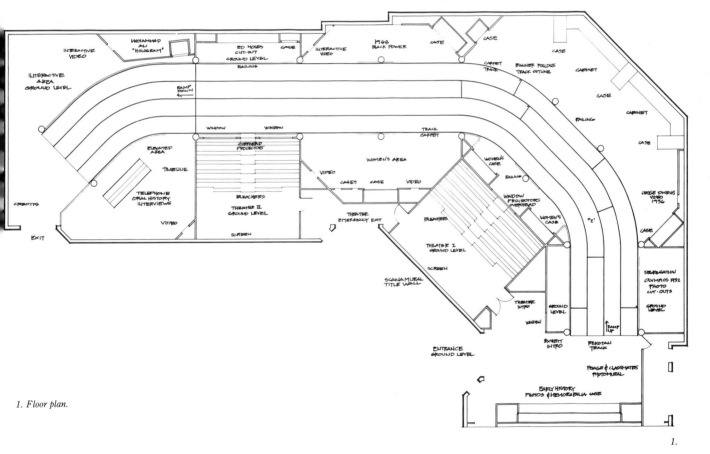

1. Floor plan.

Use of Sonotubes and Hexel kept the exhibit costs lower than they otherwise would have been, as did using an INT transfer system for texts, instead of silk-screening. Plexiglass sheets hung in front of displays, cleat-fastened to the ceiling and slipped into floor grooves at the bottom. Clear tape covered seams. College student labor also helped keep costs down. And when the exhibit was finally in place, the LAX designers could announce that they'd held costs to less than $50 per foot.

Which is not to say that the exhibit was inexpensive. The total budget was $450,000, allowing for such items as two 100-seat theaters where visitors sitting on bleachers watched 11-minute multi-media presentations, the first (near the exhibit entrance) on Black Olympians: 1904-1984, and the second (toward the exit), on the Black Power movement at the 1968 Olympics.

In addition, a two-monitor, interactive video disc installation presented a program on Black Olympic athletes in 1968, and at two other spots, video loops showed black women competing in Olympic events and black athletes, such as Jesse Owens, in Olympic action from 1904 to 1936.

The amazing thing about the exhibit was that LAX Studios designed it, sorted photos and artifacts, had it constructed and everything in place in five months. It would have been an impressive feat even under ordinary circumstances, but since the California Afro-American Museum was new, its staff still feeling its way in its duties, the facilities incomplete

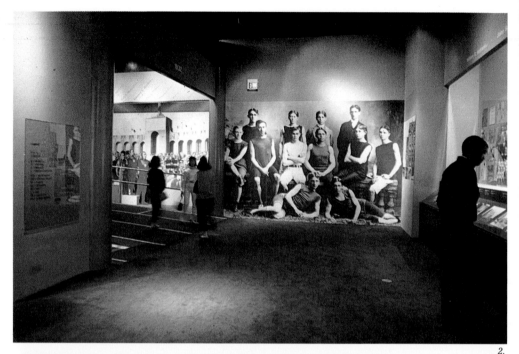

2.

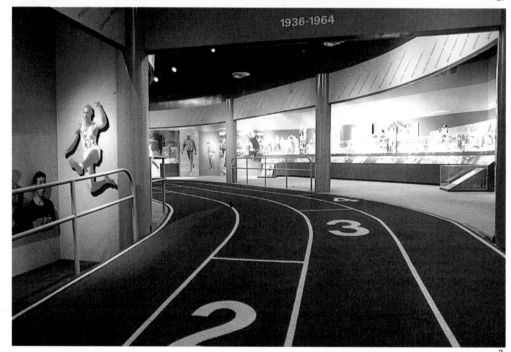

3.

2. *Exhibit entrance. At right is wall case with photos and memorabilia of early black participation in Olympics.*
3. *Visitors walked through exhibit on ramp surfaced as a running track. Floor is a cohesive part of exhibit design.*

(for instance, the museum had no woodworking shop or installation group), the bugs not yet worked out of ventilation or electrical systems, the accomplishment takes on virtually epic proportions.

Because the budget wouldn't stretch to cover outside fabrication and installation of displays, LAX Studios hired an installation foreman, who used students and artists to put the exhibit in place.

Fortunately, one staff member had solid museum experience: Curator Lonnie G. Bunch III came to the California Afro-American Museum from the Smithsonian. He gathered photographs and artifacts and went out to record interviews with Black Olympians. While Bunch was away interviewing, design had to proceed, but since Tom Hartman and Dextra Frankel didn't know yet what exactly they were going to be displaying, they devised a standard cabinet-like stand, which would fit into every display area and which could be used to mount photographs, text, or artifacts. Moreover, if the sizes or number of these items changed at the last minute, the stands could easily accommodate the changes.

Fabricated by an outside contractor, the stands were plywood-fronted with Formica. They came in widths that varied with the cases in which they were to be placed, but each rose 30″ from the floor, then slanted back at a 45-degree angle to a point 42″ above the floor. From there, the stands rose vertically for another 6″ to a flat-top 48″ from the floor. Photos and artifacts could be positioned either on the slanting

face or on the flat top.

Much of the display was photographs, some small, others blown up to photomural size, filling the 8′6″ space between the raised floor and the overhead banner. To keep the exhibit from being too static, to give it depth and dimension, the designers cut out some of the photomurals and mounted them, either standing on the floor or seeming to float on blocks that held them out from the wall. Olympian Edwin Moses, who won the 400-meter hurdles in 1976, and again in 1984, and who holds the Olympic record at that distance, is seen as a photo cutout skimming an actual hurdle (or at least the right-hand half of a hurdle). Moses's shorts and running shoes are on display, too. "He came into the museum and handed them to us," says Dextra Frankel.

At the exhibit's end was a bank of 18 phones, mounted on a Formica-laminated cabinet, where visitors listened to the oral histories of nine black Olympic athletes (the Lonnie Bunch interviews). On two walls cupping the phone bank the designers constructed a timeline of black U.S. history from 1619 to 1984. They mounted vertical strips of photos and silk-screened text. Some photos they blew up and cut out, laminating them directly to the Formica-faced walls so that they extended through two or three 12″ timeline columns.

Typefaces were Univers 67 for title blocks and 36-point Garamond for body copy.

Though the designers used Olympic stadium colors for

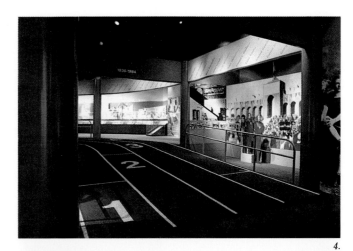

4.

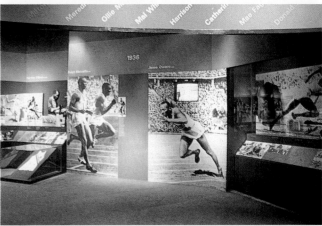

5.

6.

4. View just inside exhibit entrance. Columns and banner run through exhibit. Displays are in bays between columns.
5. Jesse Owens and Ralph Metcalfe in photo blowups.
6. Phone bank lets visitors listen to oral histories of nine black Olympic athletes. Behind phones is timeline of black U.S. history.

their props, they gave all these colors a gray hue, except for the black-and-white photos and the brick red track. The carpet was gray; the aqua on the railings was grayed. But while colors were sometimes dark, black was not used, even, as it often is, in the theaters. Bleachers in one theater were a reddish burgundy, and so were its walls and floor. The other theater had plum-colored bleachers with silver stencil numbers and a deep purple floor, ceiling and walls. Frankel and Hartman found that by giving their colors a grayed hue, they imparted a softness to an environment that could easily have become blaring.

They also used color to emphasize chronology. Photos of early Olympic athletes were sepia-toned. Photos from the '20s, '30s and '40s were black-and-white. Only in the areas dealing with more recent Olympics did the photos and videos burst—almost triumphantly—into full color.

**Client:** California Afro-American Museum (Los Angeles)
**Sponsors:** Olympic Arts Festival, Thrifty Corp., Adidas, Fenor Corp., Atlantic Richfield Corp., Los Angeles Dodgers, Luella Morey Murphy Foundation
**Design firm:** LAX Studios, Laguna Beach, CA
**Designers:** Dextra Frankel, Thomas Hartman
**Consultants:** David Inocencio and Minette Siegel (slide-sound production); Patrick Griffin (video and sound)
**Fabricators:** Arden Lichty (photomurals); Bob Olsen (photomurals); Sal Vallone (photomurals); Wavell-Huber Wood Products; James Volbert (coordinator); Tom Moore (construction foreman); construction and installation by a crew of artists, students and independent contractors

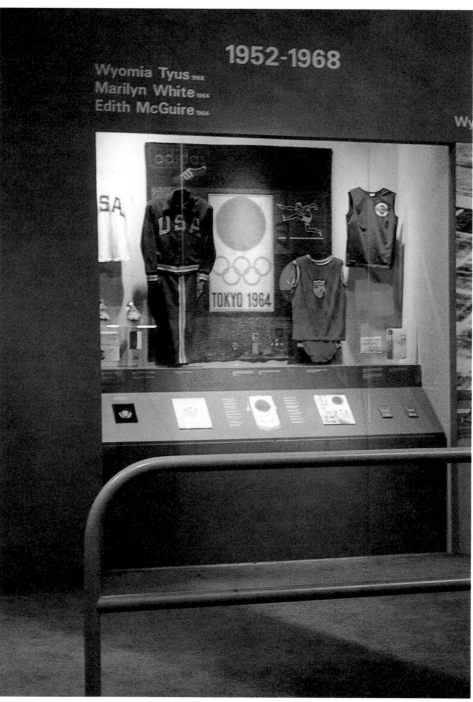

7.

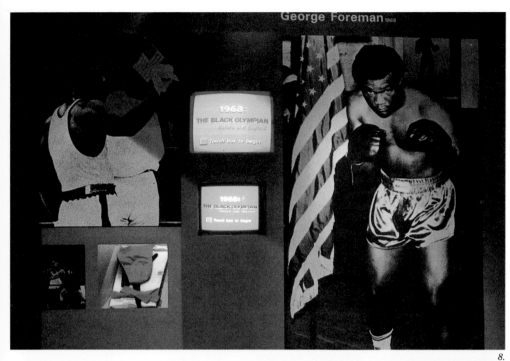

7. *Plexiglass sheet with clear tape over seams fronts artifacts from the 1964 Olympics.*
8. *Interactive video disc showed black Olympians in action on two monitors.*
9. *Timeline detail.*

8.

9.

# Los Angeles 1984:
# The Olympic Experience

A year after the 1984 Summer Olympics in Los Angeles, an exhibit commemorating those summer games opened in the Los Angeles County Museum of Natural History.

Designed, researched, curated and installed by LAX Studios, of Laguna Beach, California, in seven months on a budget of $801,000 (plus a museum contribution of $100,000 in labor), the exhibit ran for almost five months in a 4500-sq. ft. gallery (28′ by 150′ by 14′ high).

Visitors entered past a one-third-size bronze sculpture (by Robert Graham) of the gateway to the Los Angeles Coliseum and through a 20′-high, magenta-painted, scaffold archway, composed of 18″ squares in which magenta nylon tent material fluttered in the air-conditioning currents.

Inside, arches and Sonotube columns continued the Coliseum theme. And so did the colors—aquas, yellows, burgundys—all Pantone colors, "and we added others if we needed a special color in a particular spot for what we were trying to achieve," says LAX designer Dextra Frankel.

Someone called the look of the Olympics "Festive Federalism," and that is the look that the exhibit tried to recreate.

The exhibit's theme was the juxtaposition of international cultural events in the Olympic Arts Festival with the sports events of the summer games, and the exhibit brought these together by focusing on two concepts: Precision and Movement. It included, too, the torch relay that carried the Olympic flame from Greece to Los Angeles.

Right off, Frankel and Thomas Hartman of LAX realized they needed help for a project this size and complexity, and they brought in Albert Woods and Associates of New York City to edit material and prepare video discs on the Arts Festival, on Olympic history, and on the ABC-TV coverage of the Olympic events.

At five positions in the exhibit were back-lighted transparencies on touch-sensitive panels. Visitors touching a particular transparency, of, say, a male swimmer, would start a video sequence on that event, shown on wall-mounted video screens.

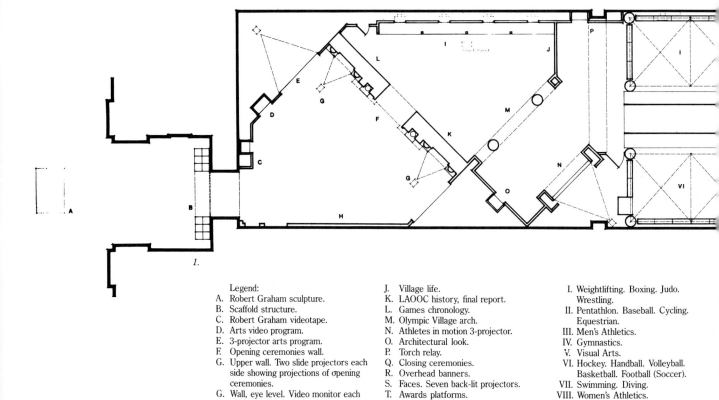

*1.*

Legend:
A. Robert Graham sculpture.
B. Scaffold structure.
C. Robert Graham videotape.
D. Arts video program.
E. 3-projector arts program.
F. Opening ceremonies wall.
G. Upper wall. Two slide projectors each side showing projections of opening ceremonies.
G. Wall, eye level. Video monitor each side with discs of opening ceremonies.
H. Marathon photomural.
I. History case/timeline.

J. Village life.
K. LAOOC history, final report.
L. Games chronology.
M. Olympic Village arch.
N. Athletes in motion 3-projector.
O. Architectural look.
P. Torch relay.
Q. Closing ceremonies.
R. Overhead banners.
S. Faces. Seven back-lit projectors.
T. Awards platforms.
U. Medals cases.
V. Credits.
W. Running track.
X. Hurdles.

I. Weightlifting. Boxing. Judo. Wrestling.
II. Pentathlon. Baseball. Cycling. Equestrian.
III. Men's Athletics.
IV. Gymnastics.
V. Visual Arts.
VI. Hockey. Handball. Volleyball. Basketball. Football (Soccer).
VII. Swimming. Diving.
VIII. Women's Athletics.
IX. Rowing. Boating. Yachting. Fencing. Shooting.
X. ABC videotape.

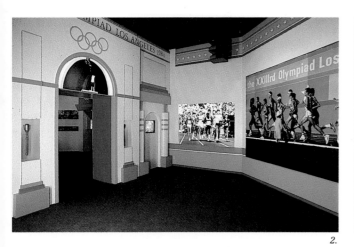

2.

3.

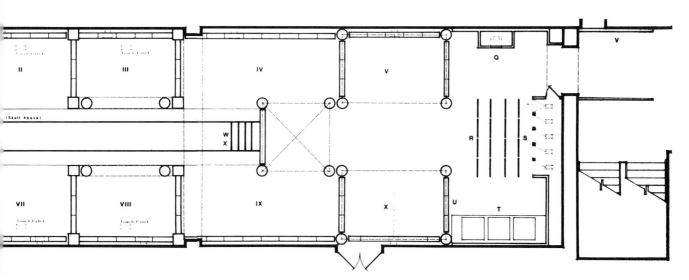

1. Floor plan of 4500 sq. ft. exhibit.
2. Throughout exhibit, arches and
   columns recalled architecture of Los
   Angeles Coliseum.
3. Exhibit is shown mirrored in blank
   video screen set into wall graphic.

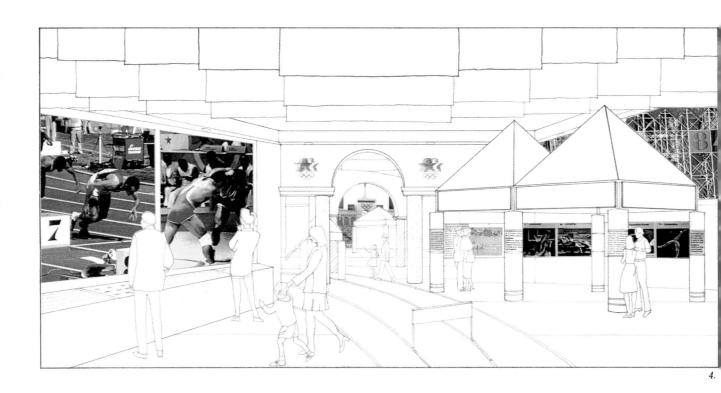

4.

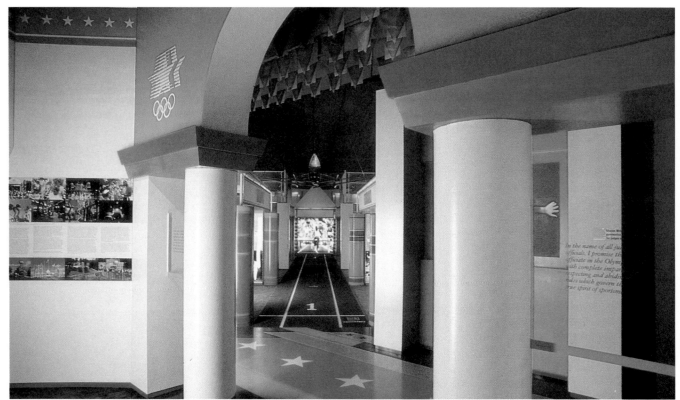

5.

**Exhibition Design/66**

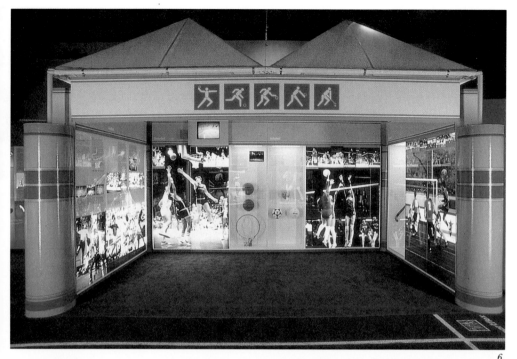

At one station, for instance, four 12″ video monitors were set into the wall within an historic timeline. This timeline of artifacts and graphics was mounted in 12″-wide strips in four 9″-deep wall cases, fronted with 8′-high by 6′-wide plexiglass. Visitors could start any of 20 video sequences on any of the modern Olympic games from 1900 to 1984 and on the Olympic achievements of women and blacks. And four positions in the exhibit offered audio-visual presentations prepared by David Inocencio's studio in San Francisco. These were on the opening ceremonies of the 1984 Summer Olympics; the Arts Festival (three projectors); and at the exhibit's end, next to the exit, across from a video of the closing ceremonies, seven projectors threw continuously changing faces, selected from 80 images, into blanks in a 20-image grid of back-lighted transparencies, making a collage of faces from the 1984 Olympics.

Past the introductory timeline, visitors moved into an area the designers called the Olympic Village—booth-like areas 9′ deep, opening on either side of a single-lane, brick-colored, Mondo-surfaced running track. Here, large, back-lighted, color-transparency blowups (5′ by 7′) with smaller inset transparencies and silk-screened text and diagrams of fields-of-play and equipment told the story of particular Olympic events: boating, yachting, fencing, shooting, swimming, diving, gymnastics, cycling, etc. And in each area a video monitor either played a fixed tape or offered a selection

4. Presentation board of exhibit section.
5. Arch, columns, single-track lane and banners all create Olympic atmosphere.
6. Photomurals and video monitor in cabaña-like bay highlight Olympic basketball.
7. At five positions in exhibit, visitors could activate video segments by touching backlighted panels.

of tapes on a pedestal-mounted, touch-sensitive panel.

Each of these booths had openings flanked by Sonotube columns. Some had tent-like roofs in various configurations of fabric and aluminum tubing. A few had cyclone-fence enclosures overhead and four were open-roofed.

The designers mounted 30″-wide text panels with clips 9″ from the wall and lighted these panels from behind with fluorescent fixtures. LAX specified Univers 67 for

headlines and captions, Univers 56 for diagrams, and Univers 44 for use in the general sports area. Throughout the exhibit, quotations were in Garamond Italic Headline type. To save money, all type was set half-size, then enlarged 200 per cent.

Of all the exhibits included in this *Casebook*, "The Olympic Experience" was the most controversial with the jurors. They were not sure it met the standards of elegance, fine detailing, quiet, almost understated, design that they

applied to their selections. Throughout the entire judging, phrases such as "lets the artifacts exhibited speak for themselves," "doesn't overpower the artifacts," "highlights the artifacts" were words of praise heard frequently in their evaluations. It was as if the exhibits they most admired were like perfect straight men, dependable, permanent and solid, against which the artifacts displayed could strut and show off. With the bright, almost brash colors

that had typified the 1984 Olympics graphics and its welter of events and personalities, "The Olympic Experience" was an exhibit that seemed to make the jury uneasy.

But they did recognize the exhibit's virtues, and they agreed to include it only because it was a temporary exhibit not meant to be—or look—permanent, or elegant, or understated. Rather, it was one they could justify as suiting its particular subject.

8.

**Client:** Los Angeles County Museum of Natural History; Lee Arnold, assistant director
**Sponsor:** Los Angeles Olympic Organizing Committee; Larry Klein, project manager
**Design firm:** LAX Studios, Laguna Beach, CA
**Designers:** Dextra Frankel, Thomas Hartman, Ralph Mechur, Linda Norlen
**Consultants:** Albert Woods & Associates (video productions); David Inocencio, Minette Siegel (audio-visual productions); George Long Photography; Los Angeles Olympic Organizing Committee; Barbara McAlpine Typography
**Fabricators:** Exhibitgroup, Inc.; Los Angeles County Museum of Natural History; Color House

9.

8. Mini-theater where visitors watched three-projector audio-visual show on the Arts Festival that accompanied the Olympics.
9. Touch panel in diving exhibit.
10. Banners and fireworks surround a video screen. Designers used a palette of colors that grew out of the bright, exuberant Olympic colors.

10.

# Raymond
# Trade Show

The Raymond Corporation exhibit at the 1984 National Electronics Packaging and Production Conference showed off the Raymond products—fork lift trucks, assembly line equipment (i.e., computerized production distribution systems) and storage racks—but it also unveiled a new Raymond corporate image. As designed by Vignelli Associates, of New York City, both the exhibit, which is meant to be reused, and the corporate image are bold statements.

Hidden behind corrugated sheet steel walls, which snaked around the 3000-sq. ft. Raymond show site, the exhibit had antecedents in circus sideshows. Like a sideshow tent, the corrugated walls, painted an assertive, provocative "Raymond orange," shielded what was within, piquing one's curiosity. And to help lure show-goers in, the designers positioned four Raymond fork lift trucks outside the corrugated walls, holding loads high above the exhibit floor where they could be seen throughout the trade show. Twin fork lifts at the exhibit's main entrance held their loads within a steel-grid framework of simulated storage racks.

The Vignelli designers used corrugated panels because these suited a storage and manufacturing image. Fabricated in 8'-high, 9'-long sections, the panels have enough design flexibility to suit future installations. Sections curve on a 9' radius, supported by the 1½" steel frames to which they are pop-riveted. Even the two 4'-by-4' curved reception counters, one at each

of the exhibit's two entrances, were of corrugated sheet steel.

The entire Raymond exhibit sat on a 50'-by-60' rectangular, industrial-gray acrylic carpet.

Inside, the corrugated panel walls were unpainted, as they would be in a manufacturing plant. They surrounded a layout of Raymond's computerized assembly-line conveyors and banks of 19" TV sets, stacked three-high in two 24-set groupings on steel frame carousels which the Raymond Corp. manufactures to hold equipment during post-manufacture testing.

These TV sets all played identical tapes of the Raymond corporate story, 48 sets all occasionally projecting the same, bold Raymond logo.

Information about each particular Raymond product was silk-screened on the back of clear, 36"-by-36" acrylic panels, which hung on nylon line from S-hooks atop the corrugated walls.

Vignelli Associates designed and supervised installation of the exhibit in three months on a $123,000 budget.

**Client:** Raymond Corp. (Greene, NY)
**Design firm:** Vignelli Associates, New York, NY
**Designers:** Lella and Massimo Vignelli (principals-in-charge), Peter Laundy, David Law, Michelle Kolb
**Consultants:** Jay Doblin and Associates/Larry Kelley
**Fabricator:** The Exhibit Co.

1. *Corrugated steel panels form perimeter of Raymond booth.*
2. *Floor plan.*
3. *Raymond logo and fork lift holding palletized load are all that visitors see before entering booth.*
4. *Graphics on acrylic panels hang against corrugated wall.*

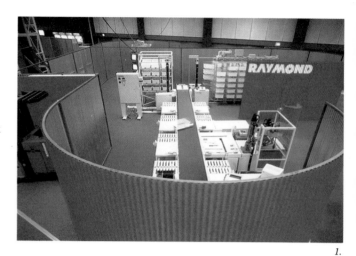

1.

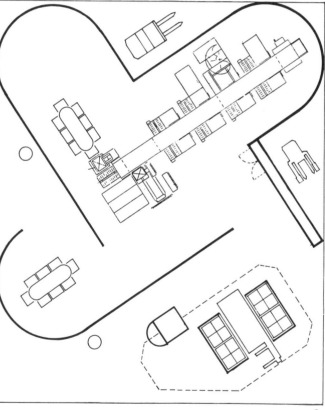

2.

3.

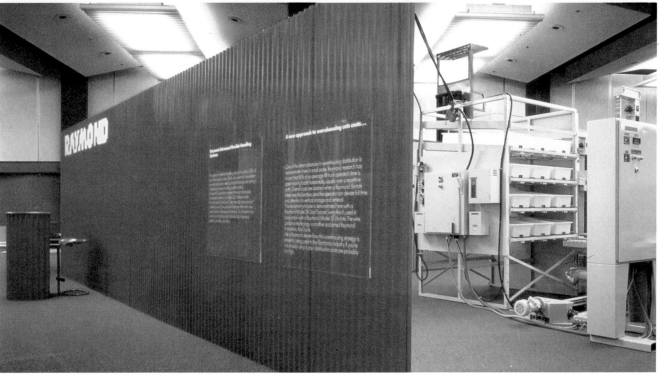

4.

# Aditi: A Celebration of Life

"Aditi" is a Sanskrit word meaning the creative power that sustains the universe, and, too, Aditi is the name of the Indo-Aryan goddess who symbolizes the cyclical nature of life—the paradox of the parent creating and being created by a child. "Aditi" was the inaugural exhibition in the U.S. of the 1985-86 National Festival of India.

For six weeks in 1985 the Smithsonian National Museum of Natural History hosted this exhibition, which celebrated the specific creativity that surrounds the rituals and festivals associated with birth, coming of age, marriage, conception, and birth again in rural India. Celebration is a particularly apt word for the exhibit, for with its colors, music, live performers, artists, and religious ceremonies, it had enough exuberance and life to be a festival all by itself. It tried to show how crafts, art and religion are all tied in with everyday life in India, and it succeeded far better than any static exhibit could have.

Besides displays of Indian crafts, artifacts and art, the exhibit contained the performances and activities of 40 artists who danced, sang, painted, wove and prayed throughout the exhibit's six-week stay at the Smithsonian.

To say that the exhibit was part theatrical performance is not entirely misleading, for it had a director, Rejeev Sethi, who had conceived the idea of "Aditi" and had produced a version of it in London in the summer of 1983. But for the exhibit's designer the concerns were the same as those for a more traditional exhibit: traffic

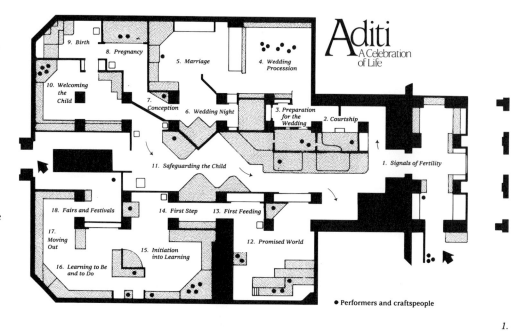

1.

2.

1. *Floor plan.*
2. *Exhibit brochure featured 18th-century wooden manuscript cover depicting Kama Dhenu, who emerged from an ocean of milk.*
3. *Papier-maché figures. View is toward the first of a series of courtyards.*
4. *Chandrakala Devi paints papier-maché column of miniature wedding hut she made for exhibit.*

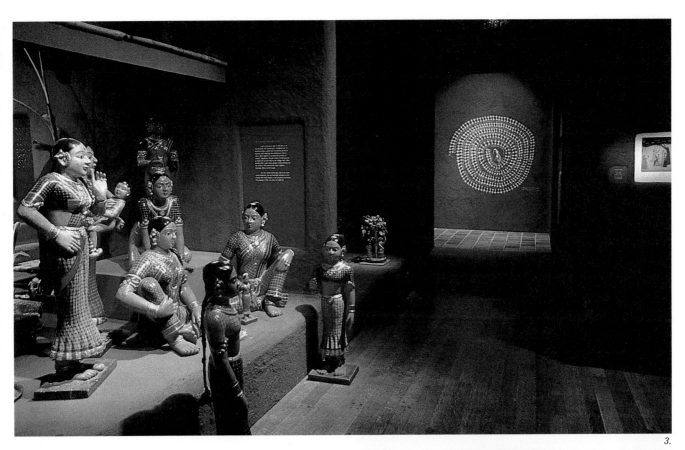

*3.*

flow, security, graphics, colors, lighting and display.

Designers from the Washington, DC, firm of Miles Fridberg Molinaroli, Inc., wanted to display the creative activities surrounding various key events in Indian life with the artifacts and art that these events inspired; and to that end they designed a series of 17 thematic areas that pertained to courtship, wedding processions, marriage, pregnancy, birth, welcoming the child, initiation into learning, and so on.

In all, the exhibit had 15,000 sq. ft. of space, which included 2000 sq. ft. of introductory lobby area. It was in this introductory area that the 40 performers and artists held morning and evening prayers.

In the 15,000 sq. ft., the designers tried to recreate India. "I wanted it to be a slice of India, not a museum display," says Beth Miles. She wanted to convey the way performers, objects, and craftspeople are part of everyday Indian life, and to do this "we had to minimize barriers between audience and performers and between craftsman and object." What they tried to avoid were formal stages and seating areas, electronic amplification of

*4.*

music, vitrines, and any marked contrasts in materials, lighting or color between the settings for museum pieces and those for contemporary handicrafts.

All this was difficult because the Smithsonian has strict rules about protecting behind-glass items borrowed from other museums. To some extent, Miles achieved the effect she wanted by grouping items that had to be protected in floor-to-ceiling wall cases (which were less obtrusive than small vitrines) and by leaving some of the larger sculpture items in the open, after making sure they were beyond the reach of visitors. When they did use wall cases or vitrines, the designers carried the surrounding colors into the cases.

Setting up displays was difficult because the designers weren't sure what they would have to display until the last minute. Beth Miles and Richard Molinaroli went to India, traveling with the show's director, Rajeev Sethi, searching for items he wished to display. For a month they measured, photographed and took notes in museums, private homes, villages, markets, ruins and temples. They even collected seeds from the sacred tulsi plant, which the Smithsonian grew into plants and placed in the exhibit's wedding procession area.

But even when the designers returned to Washington, they weren't sure which items were going to arrive, or when. In all, there were to be 1500 items shipped from India, along with some 10,000 tiles, for use in building roofs, on floors and in display cases, and a pair of specially carved 12'-high teak

5.

6.

7.

doors. Shipments kept arriving, sporadically, up until two days before the opening.

One thing that impressed the *Casebook* jurors about "Aditi" was the way the designers integrated explanatory copy with the exhibit. Some other exhibits, they noted, seem to give no thought to that integration. Main exhibit texts and graphics were all silk-screened on panels or ceramic tiles, and sometimes these were set into the simulated mud walls of the village houses that made up the first stages of the exhibit. But because the designers didn't know precisely what they would be exhibiting until the last minute, they couldn't silk-screen all the labels to get the permanent look they wanted. Instead, they set type (in ITC Usherwood) and made up sheets of dry-transfers in selected Pantone colors, which they burnished onto surfaces after the objects were installed. The dry-transfers were not ideal, says Beth Miles, because by the end of the exhibit's six-week stay they had started rubbing off.

Since they had only 7½ weeks to install the exhibit, and since they wanted to prefabricate the mud walls in the exhibit's early sections, the designers devised a method for doing this within the time frame. Cutting styrofoam into particular shapes, they covered it with a sludge of Deccadex, to which they added sand and pigment. Not only did the Deccadex look surprisingly like the mud walls of an Indian village, but it also met the District of Columbia fire codes, and the surfaces could be smoothed out so that village

5. Artists demonstrate traditional art of glass-painting during exhibit hours.
6. Figures in a shrine in "Safeguarding the Child" area.
7. Volunteers from Washington, DC's Indian community recreated this bazaar stall for the exhibit.

artists could paint scenes on the walls. These artists did a good deal of painting in front of visitors. And at one point, the museum was able to cut out a courtyard wall section and replace it so that the artists would have a fresh surface to work on.

The Indian government sent all 40 artists and performers to the U.S. and paid for their housing. They slept in dormitories at Georgetown University, traveling back and forth to the Smithsonian by special buses. Working usually from 11 a.m. to 4 p.m. (the exhibit was open 10 to 5), they had Mondays off. And they performed pretty much at their own pace, with no fixed schedules.

The designers knew the exhibit would draw crowds, and they tried to avoid bottlenecks by arranging areas for the performers that were not formal stages, but merely wide places in the exhibit's labyrinth-like pathway. But despite this design planning, and even though the museum limited attendance by ticket to 300 persons at a time, visitors still were backed up around the performers. Volunteers, members of the Washington Indian community, retained by the museum to serve as interpreters, would urge visitors on once a performance was over. And of course, music in another part of the exhibit would help lure people on. Too, Miles Fridberg Molinaroli used

lighting and color to pull visitors through the exhibit. While transitions between exhibit sections were mostly signalled by wall graphics, MFM set up a rhythm of lights and colors, varying the lighting from dim in public areas to well-lighted in areas for the performers, and using a system of lighter and stronger colors. Most of the exhibit's colors were the red earth colors of mud walls and tiles. Red is a symbol of fertility in India.

Cases were modular, based on the 6″ by 6″ of their floor tiles, and pedestals were modular, too, based on a tile size of 2″ by 2″.

Miles Fridberg Molinaroli had about 10 months to research, design and install the exhibit;

and they did it on a budget of $545,000, which included not only design and installation, but also programs and staff salaries.

**Client:** National Museum of Natural History, Smithsonian Institution (Washington, DC)
**Sponsors:** Smithsonian Institution, Government of India, Air India, Indo-U.S. Subcommission on Education and Culture, Armand Hammer Foundation, and Chicago Pneumatic Tool Co.
**Design firm:** Miles Fridberg Molinaroli, Inc., Washington, DC
**Designers:** Elizabeth Miles, David Fridberg (print graphics)
**Curator:** Rajeev Sethi (guest curator/project director)
**Consultants:** Ellen Eder (graphics), Robert Heiderer (photography)
**Fabricator:** Creative Dimension Group, Inc.; Sanders Design

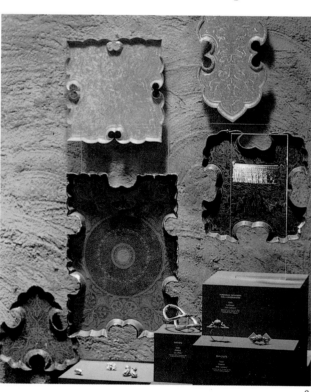

8.

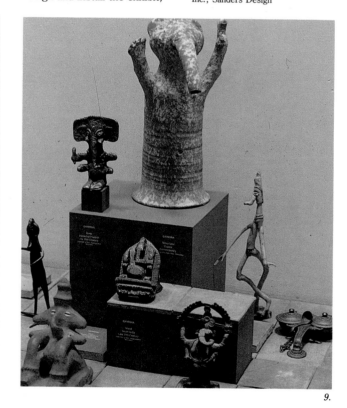

9.

8. *Detail of case displaying dowry jewelry and other gifts.*
9. *Figures of gods and goddesses. Several of them are displayed on handmade tiles, which are also used as surfaces for graphics.*

# Circles of the World: Traditional Art of the Plains Indian

Some 150 objects from the Denver Art Museum's extensive 16,000-item collection of Native American art traveled to eight museums in the U.S. and Europe.

Conceived and organized by Richard Conn, the Denver Art Museum's curator of Native Arts, the exhibit contained everyday and ceremonial clothing and artifacts—spoons, cradles, earrings, feathered-headdresses, bowls, robes, beaded moccasins, dolls, saddles, pipes, spears, fans, rattles, even a small tipi. Conn selected the items specifically as representative of those fashioned by the Plains Indians, the nomadic tribes which followed game across the American Great Plains between the Mississippi and the Rocky Mountains.

The Plains Indians had two general esthetic principles: appropriateness and harmony. And these were the principles evident in the installation of "Circles of the World" shown here—that of the Museum of Fine Arts, Boston.

The Museum of Fine Arts' chief exhibit designer, Judith G. Downes, designed an open space for the exhibit. She had the gallery walls spray-painted in three ascending bands to suggest a misty surround of land, ground fog and forest, and she arranged objects on platforms and in vitrines whose green-brown pedestals disappeared against the same-colored background of the walls.

To the Plains Indian, the circle symbolized the eternal continuity of life. A circle was the ideal form. It was what he saw as his gaze swept the

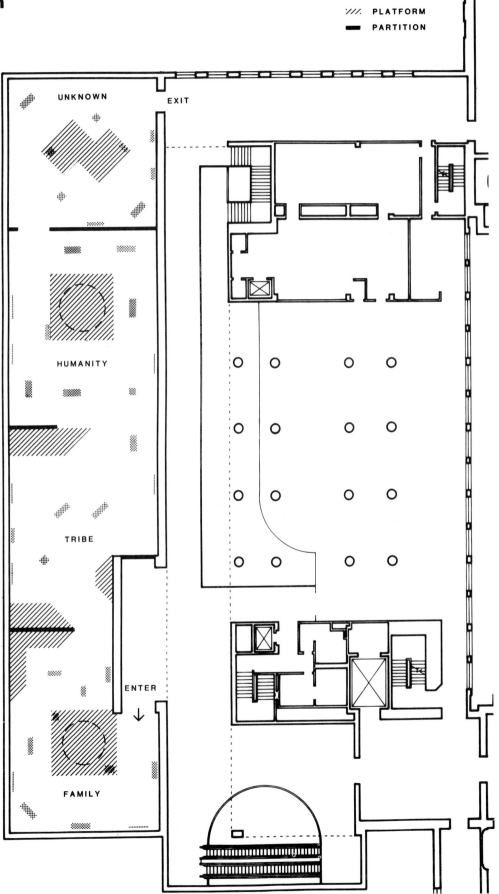

WALL HANGING
CASE
PLATFORM
PARTITION

UNKNOWN

EXIT

HUMANITY

TRIBE

ENTER

FAMILY

*1. Floor plan.*

# CIRCLES OF ✦ THE WORLD

## Traditional Art of the Plains Indians

2.

horizon around him on the flat plains. A circle was the base of his home, the tipi, and a circle was the configuration of his camps. On an intellectual level, he saw the universe as a series of concentric circles "beginning with the home and extending finally to the infinite."

And these circles, from which the exhibit took its title, also became the exhibit's divisions.

Immediately preceeding "Circles of the World," the 10,000-sq. ft. gallery housed a print exhibition in a series of small (15' by 30') spaces. Downes wanted plenty of open space for "Circles," partly to handle school groups that came in batches of 20 or so for lectures and sat about the gallery, and partly to give a sense of the open plains.

To open up the space, wall partitions had to come down, and to save time and money (and because the 14'-by-10' wall partitions were too big to move out of the gallery), Downes conceived a special hydraulic lift. The lift slipped beneath the 14'-high plywood-and-2x4-stud wall partitions and lowered them to the floor, where they became platforms. When the exhibit was over, the hydraulic lift picked up the platforms and set them in place as partitions for the next exhibit.

Judith Downes says three men with the hydraulic lift can re-partition the 10,000 sq. ft. space in three days. When upright, the partitions fit into grooves in the ceiling skylight grid. And on the floor, the platforms go anywhere the designer wants them to be. For this exhibit, Downes used

several platform configurations, the largest being one 20' square for tipis, and one 15' by 30' composed of two partly juxtaposed platforms which held ceremonial clothing in the exhibit's last section. Platforms rose 9″ to 12″ above the floor and held speakers that broadcast bird songs and tribal music into the hall. Visitors entered the exhibit's last section, "Circles of the Unknown," through a tipi-shaped cutout in a wall partition that isolated the gallery's entire far end. Inside, the mood changed from brightly lighted

openness to dark somberness. The designers covered the skylights in this part of the gallery with black screens. Two screen-covered frames slipped behind the ceiling lighting tracks to cover each 5'-by-5' skylight. Below, in this otherwise dark, red-walled section, the ceiling spots isolated individual objects.

At the exhibit entrance, an 8'-high-by-40'-long graphic of the American plains beckoned to visitors. Flanking it was text in Palatino and Palatino Bold typeface, screened on Masonite panels painted the same

burgundy of the partitions to which they are tacked. Also in this introductory area was the show's logotype, almost 14' high, announcing the show title above Plains Indian paintings of mounted warriors.

The designers worked within a budget of $25,000, which included labor and materials, and construction of the special hydraulic lift. Although they had three months of design and preparation time, they were actually able to install the exhibit in 15 working days.

**Client:** Museum of Fine Arts (Boston)
**Sponsors:** American Express Foundation, National Endowment for the Humanities, National Endowment for the Arts
**Design firm:** Museum of Fine Arts Design Office
**Designer:** Judith G. Downes
**Curators:** Richard Conn (Denver Art Museum), Jonathan Fairbanks (Museum of Fine Arts, Boston), Wendy Cooper (assistant curator, Museum of Fine Arts, Boston)
**Fabricators:** Museum of Fine Arts building and grounds staff; Future Plastics; Holder Electric Co.

3.

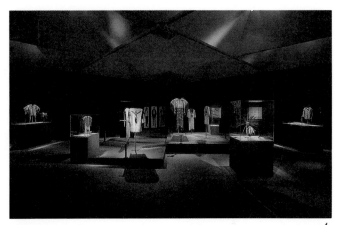

4.

5.

2. Directional sign graphics.
3. Tipi-shaped entrance to "Circle of the Unknown" section.
4. Costumes and ritual objects lighted theatrically in "Circle of the Unknown" section.
5. Forty-foot-long graphic of the American plains at exhibit entrance.

6.

7.

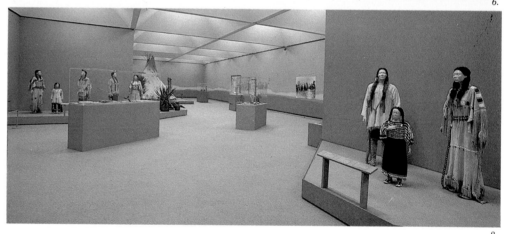

8.

6. Plains Indian tipi with tipi-shaped
   portal in wall beyond.

7. Specially designed hydraulic lift lowers
   wall partition to floor where it becomes
   artifact platform.

8. Tribal clothing on manikins.

# U.S. Theme Pavilion, Tsukuba World's Fair

Housed in an airily soaring tent, the U.S. Pavilion at the Tsukuba (Japan) World's Fair had enough space to house some corporate exhibits, an auditorium, and 20,000 sq. ft. of the U.S. Theme Exhibit, which dealt with the development of the computer and attempts to create an artificial intelligence. Herb Rosenthal & Associates, of Los Angeles, who designed the theme exhibit for the U.S. Information Agency, worked on it for a year with an exhibit budget of about $2,000,000.

At first, the Rosenthal designers considered a purely audio-visual show, but rejected that because they wanted more interaction between visitors and the exhibit. What they came up with had enough color and motion to enchant almost anyone, but in the end, they had fewer interactive devices than they had originally hoped for.

The exhibit started outside the pavilion with a giant fountain of lights 18′ high and 22′ in diameter. Its thousands of lights flashed in sequences of orange, red, yellow, green and white to give the effect of falling water. A close look revealed that the fountain's structure was made up of thousands of electronic parts.

To reach the exhibits inside, visitors first moved through a corridor lined with a montage of silhouetted anonymous heads. Initially, the heads seemed fuzzy, but as one neared the end of the corridor, the heads came into focus. Symbolized

was a journey from disorder to order, and the soundtrack that went with it dramatically underscored the ultimate discoveries that follow man's initial doubts about meeting formidable challenges. A voice says with certainty: "Man will never fly." And as if in response you hear the roar of a 727 taking off. A voice says: "Man can build a computer but never artificial intelligence." Another voice says: "We're working on it." Each panel in the corridor was a light box composed of children's toys. These toys have surfaces in which movable colored pegs can be arranged to form an image when lights go on behind them. Hundreds of these toys went into the corridor's panels, and they shimmered with the glow of thousands of lights.

In the first exhibit space within the pavilion, the designers wanted to get across the point that—unlike many of man's other mechanical inventions—computers become smaller as they achieve more sophistication. Their path has been different from, say, the ship, the locomotive, or the airplane. This size factor has great implications for artificial intelligence and visitors saw huge mockups to illustrate the idea. A giant transistor hovered at one end of the space, for instance, and in a case beneath it was an actual, tiny transistor. At the other end was an oversized wall-plug with a fat wire leading to a large, wall-mounted plexiglass box holding a mammoth tangle of computer

1.

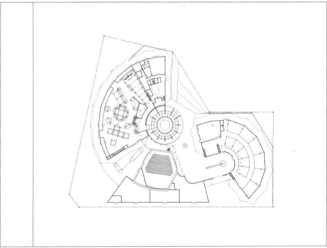

2.

1. Fountain of light 18′ high, composed of thousands of electronic parts, outside U.S. Pavilion.
2. Pavilion floor plan.
3. Sectional drawing.

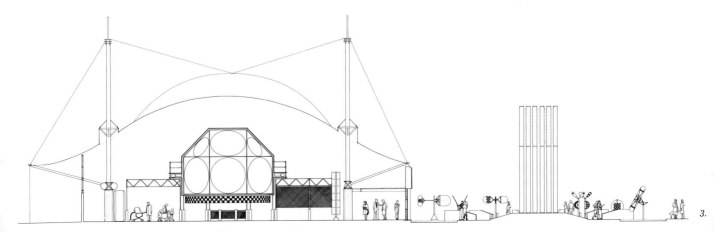

3.

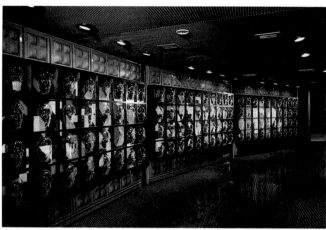

4.

5.

wiring. A glass-and-painted-wood reading rail told the story of shrinking computers with display devices such as diodes, vacuum tubes, etc., as well as with graphics and text. Next, visitors saw a three-minute video-monitor film. It compared visually the network of cells and ganglia in the human brain, the network of transistors and wires in the computer, and the network of human society. Surrounding the raised video screen, a curved steel framework held 14 photo blowups, 18″ by 24″, that reinforced the point: photos of hands, eyes and ears—the human sensory organs—next to photos of microphones and video speakers. Each of the photos was sandwiched between glass in back and plexiglass in front, so that each seemed to be floating in light. Two 14″ by 18″ copy panels stood next to the video monitor on raised stands, with the plexiglass section covering the copy sandblasted to make the copy seem to float.

In another of the exhibit's sections, the idea of human organic and inorganic networks linking all nations was reinforced by a grouping of wheel-like discs. As one wheel turned, it seemed to turn the others. Each wheel had a central graphic representation of either an organic or inorganic network, and the periphery of each was ringed by representations of the flags of various nations. Text was atop slender stems on lollipop-like discs, standing in front of the wheels.

Herb Rosenthal had specified two walls of light box-mounted photo blowups to be lighted sequentially around a small stage, on which performers would present several shows written by the designers. But by the time Rosenthal got to Japan to oversee construction, the audiovisual budget was depleted and pink and green panels had been substituted for most of the photographs.

On stage, using props such as a robotics arm and a flower made up of dozens of audio speakers on a long stalk, demonstrators went through their shows while images flashed on a video screen behind them. One such demonstration showed how a computer approached the problem of designing packing cases for 10,000 champagne glasses: The computer searches its memory, first for what champagne is, then for what a glass is, and finally for a way to pack them. Perhaps someday, the show said, computers will be able to learn from their mistakes and be able to store what they have learned. In the show, the computer takes three minutes to reach a solution. In reality, said a video screen message, it would take 3½ seconds.

The demonstrators in these shows called on persons from the audience to do different tasks, and Rosenthal says that, at least at Tsukuba, this was the kind of exhibit-visitor interaction he felt most comfortable with. He says he's not certain how well participatory electronic or mechanical devices work at world's fairs, where only a few visitors out of millions have the opportunity to work them.

Nevertheless, the U.S. Theme Exhibit at Tsukuba had interactive devices, almost all of them in the final exhibit areas— a Children's Corner and an Artificial Intelligence Laboratory—after visitors had passed through more static areas explaining the exhibit's message.

In the Children's Corner, youngsters could play a series of electronic games designed to show that even our most advanced computers are barely equal to the intelligence of a five-year-old. A child would select two like faces from a panel by pushing a button. A computer can barely distinguish a face from, say, an apple.

And in the Artificial Intelligence Laboratory, visitors could actually do things with real computers lent to the exhibit by American companies.

The designers thought one of their biggest problems would be lighting. The tent material let enough light through so that dramatic, independent lighting of the exhibit components could have been difficult. But the solution—increased interior

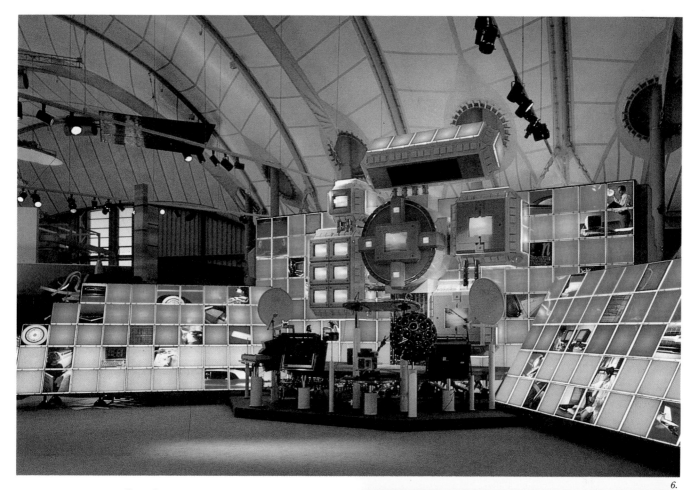

6.

wattage—was uncomplicated. Herb Rosenthal says he found that, if you pump enough light onto something, it stands out from the ambient lighting.

4. *Giant electronic components illustrate that as computers get more sophisticated, they get smaller.*
5. *Corridor lined with a montage of silhoutted anonymous heads.*
6. *Lightboxes surround small stage where demonstrator-performers worked with props.*
7. *Behind the video screens are blowups of human sensory organs and electronic-sensing apparatus. On screen, three-minute film compares human brain with wires and transistors in computer.*

**Client:** U.S. Information Agency (Washington, DC)
**Design firm:** Herb Rosenthal & Associates, Inc., Los Angeles
**Designers:** Herb Rosenthal (chief designer); Ed Roberts, Steve Wilson (designers); Mark Rosenthal (illustrator); Paul Rosenthal (writer)
**Consultants:** Jones & Cooper (electrical engineers)

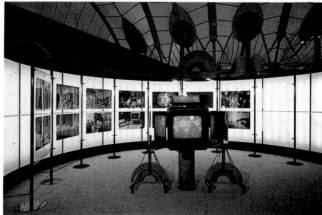

7.

# The Palace of Commerce: U.S. Custom House

Built at the turn of the century, the U.S. Custom House in downtown Manhattan, a magnificent marble Beaux Arts structure designed by Cass Gilbert, has stood vacant since 1973. Now, however, it is being renovated by the General Services Administration to house federal offices and provide 50,000 sq. ft. of public space, which will be leased to conservation or arts groups.

While this work goes on, people passing through the plaza in front of the Custom House can learn something of the building and the area—their history and future—by stopping at a small but delightful exhibit sponsored by the New York Landmarks Conservancy.

Keith Godard, of Works, the design firm that designed the exhibit, says he got the idea for the exhibit structure from looking at New York City bus shelters. These aluminum frame shelters have advertisements sandwiched in glass panels that form the shelter walls.

Works' exhibit—"The Palace of Commerce"—follows roughly the same idea.

For a while, Works toyed with the idea of an enclosed exhibit which could be viewed through peepholes from the outside, as if looking into a construction site through the surrounding fence. But no light would get into such an exhibit and it might become a garbage collector, they reasoned. So the pavilion, which is the final solution, is open on top and sides to the rain, which washes it, and to the sun, which lights it.

Godard designed it in no particular style, but it roughly mirrors the architecture of the Beaux Arts Custom House behind it. He fashioned columns from 4″-diameter electrical tubing and a roofless mansard top from plywood with ornament of found pieces and shapes gathered in lumber yards. The wooden flooring of 5′-by-3′ wooden slabs picks up the pattern of the Custom House flooring.

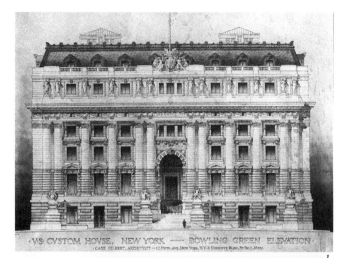

1.

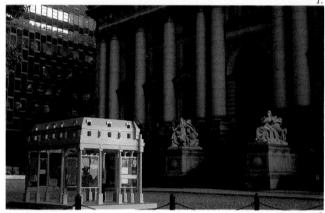

3.

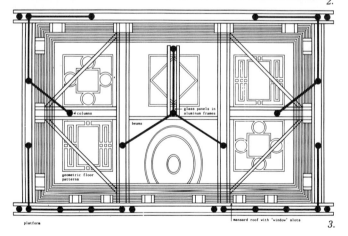

2.

1. *Front elevation, U.S. Custom House, New York City.*
2. *Exhibit stands in front of Custom House.*
3. *Exhibit plan.*

Passersby can see visitors standing in the pavilion, or if no one is there, see only the panels of text and photos that tell the Custom House story.

These 34 panels are sandwiches of graphics covered by two sheets, of ⅛″ safety glass and vinyl sheet, held in aluminum frames with silicone sealant to keep moisture off the graphics.

Garamond is the typeface for titles and text.

Godard wanted his 12′-high, 250-sq. ft. exhibit to look appealing and gay in front of the imposing Cass Gilbert Custom House. And the gaiety comes from color. Exhibit columns are pink, the roof line turquoise. Ochre and turquoise show up on graphic panels and so do large black silhouettes of figures in turn-of-the-century clothes.

Works designed the exhibit on a budget of $26,000, which came from funding by the National Endowment for the Arts, New York State Council on the Arts, and the Custom House Institute.

**Client:** New York Landmarks Conservancy (New York City)
**Design firm:** Works, New York, NY
**Designers:** Keith Godard (partner-in-charge), Janet Giampietro
**Curator:** Deborah Nevins
**Fabricator:** Gary Faro

4.

*4. Exhibit uses graphics suspended within open pavilion that has architectural details roughly mirroring those of the Custom House.*
*5. Graphics suspended in glass panels in aluminum frames.*

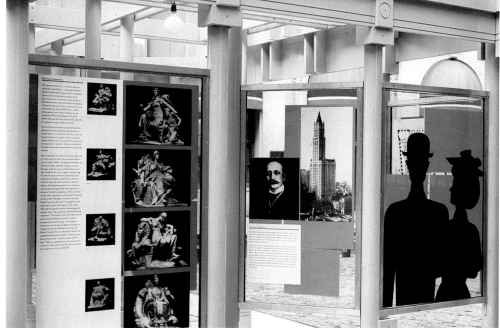

5.

# JungleWorld

Working with a $10-million exhibit budget, a team of zoologists, horticulturists, audio-visual experts, model makers, photo researchers, sculptors, painters, exhibit designers (as many as 28 at one time) and exhibit fabricators designed and put in place a one-million-cubic-foot rain forest at New York City's Bronx Zoo. Not just any rain forest, but four distinct, exactly replicated Asian rain forest habitats are home to a cornucopia of

mammals, birds, reptiles, amphibians, and probably eventually insects in a greenhouse-roofed building shell. Nothing on this scale had been attempted before, so the project was, and is, experimental, and its design is continually being modified.

The zoo had two goals: to see if endangered species—such as the rare proboscis monkey—would reproduce if gathered in large enough groups (JungleWorld has seven of these

monkeys, the only ones in the U.S.), and to educate visitors on the beauty and wonder and the overwhelming global importance of rain forests. The New York Zoological Society's general director, William G. Conway, who conceived the project, has said: "Tropical forests now cover but six per cent of the world's land area, yet provide essential habitat for more than 50 per cent of all the kinds of plants and animals on earth. They determine the

1.

1. *Drawing of pied hornbill from India, an inhabitant of JungleWorld.*
2. *JungleWorld plan.*
3. *Pool and artificail rocks, all created by exhibit designers.*

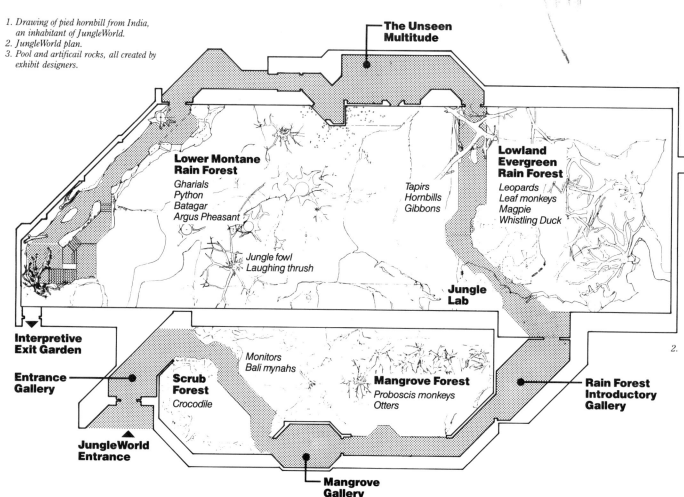

**The Unseen Multitude**

**Lower Montane Rain Forest**
*Gharials*
*Python*
*Batagar*
*Argus Pheasant*

*Jungle fowl*
*Laughing thrush*

*Tapirs*
*Hornbills*
*Gibbons*

**Lowland Evergreen Rain Forest**
*Leopards*
*Leaf monkeys*
*Magpie*
*Whistling Duck*

**Jungle Lab**

**Interpretive Exit Garden**

**Entrance Gallery**

**Scrub Forest**
*Crocodile*

*Monitors*
*Bali mynahs*

**Mangrove Forest**
*Proboscis monkeys*
*Otters*

**Rain Forest Introductory Gallery**

**JungleWorld Entrance**

**Mangrove Gallery**

2.

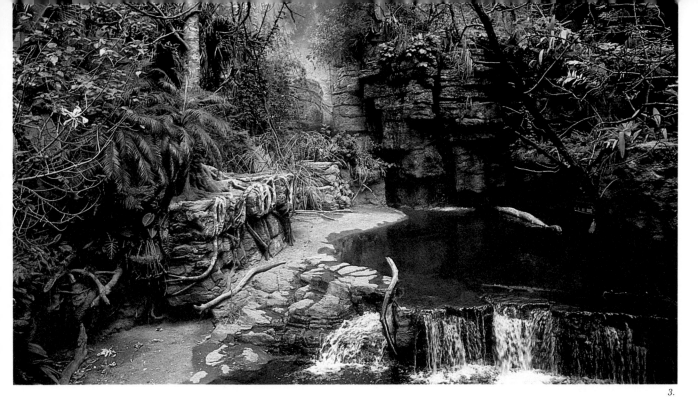

3.

quality of our air, sustain vital water tables, affect rainfall and, most importantly, are our richest storehouse of genetic diversity. They are now being cut down or burned at a rate of about 50 acres each minute."

JungleWorld visitors are immersed in the rain forest. They walk through and around it, separated from the trees, plants, water and animals only by a guard rail (or at most by occasional sheets of glass, positioned so the lack of glare from lights makes them nearly invisible).

To present the exhibit's message, which is strongly conservationist, the exhibit relies on the rain forest itself, and on four separate, walled galleries on the rain forest's edges. Visitors walk through rain forest and galleries on a slightly elevated walkway that widens and narrows from 11′ to perhaps 6′ at its narrowest. Each of the four galleries introduces one of the four forest sections: scrub forest;

mangrove forest; lowland evergreen rain forest and lower montane rain forest. In these galleries, wall cases hold animals too small to be loosed in the adjacent forest, and the walls support graphics, some of which repeat JungleWorld's message: that we need the rain forests.

Following each exposure to an explanatory gallery, visitors plunge back into the rain forest to watch monkeys, birds, reptiles and amphibians in their natural habitats.

Finally, as they leave (the average visitor spends 31 minutes in JungleWorld) visitors pass electronic counters ticking away on raised columns in a garden beyond the exit. One counter shows the eroding rain forest acreage, lowering the figure each minute by 50 acres. A nearby counter adds to the total worldwide human population: 150 new inhabitants a minute.

The Zoological Society's Exhibition and Graphic Arts

Department (EGAD), headed by curator John Gwynne, not only designed the exhibits in the small introductory galleries, but also designed all of JungleWorld's graphics, plus a good deal of the rain forest terrain, including rocks, caves, pools, trees, shrubs and vines. Some of the plants are real, but some are not. Instead, they are carefully constructed of steel frames and epoxy sheathings painted and etched to be almost indistinguishable from the real thing. Gwynne and his designers fabricated the forest's larger trees and vines and covered them with real plants. For instance, one huge fabricated log, overgrown with orchids and other epiphytes, holds and hides the steel framework for a 20′ mullionless window that lets visitors inspect the underwater portion of a pond for gharial crocodiles. The log also holds drainage and watering devices for the plants, and one of its inner crevices contains a heating, cooling and

light system that keeps an Asian rock python comfortable.

The arrangement of the plantings had to be exact, and the natural elements such as streams, waterfalls, mudbanks and rock faces were carefully designed and positioned both to hide the skylighted building and to create barriers between human visitors and animals living in the forest.

Rear walls were incorporated into the exhibit by becoming surfaces for huge dioramas, one 17,500 sq. ft., which may be the largest ever painted. And the designers sheathed an offensive structural column in mirrors and partly hid it behind a mudbank so that it disappeared into the greenery. Pergolas covered with vines and flowers extended over the walkway to hide the skylight, and vistas designed into the forest channelled visitors' gazes away from the building walls. "Anyway," says designer John Gwynne, "the vegetation is growing now and starting to

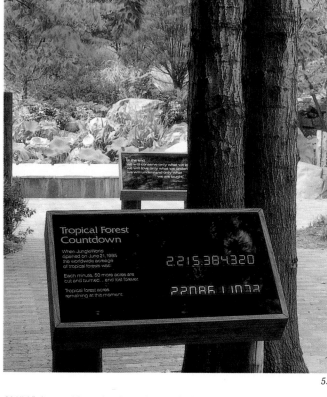

4.

5.

obscure building elements like beams."

Also hidden by the forest are fogging machines that send fog-like sprays from waterfalls and treetops.

Loudspeakers provide a background of rain forest voices—crickets, doves, frogs, and so on. Gwynne wanted a general background sound, one not too harsh or particular, and that's what he told the audio team that went to a Thailand rain forest to make the recordings. These background sounds play through 24″ speakers hidden by vegetation in the outer reaches of the zoo's rain forest. More individual

sounds, such as that of a single cricket, come from 6″ speakers built into epoxy logs or concrete rocks close to the walkway.

The exhibit's conservation message is repeated again and again with graphics and photos and small displays—even a videotape of rain forests being cut down—but in the natural habitats the designers kept the graphics quiet, purposely understating them. The rain forest's only graphics are on a

2½″-high graphic strip slanted toward viewers from the top of the handrail that stands 42″ high at the walkway's edge between visitors and the rain forest. Beneath the rail, supporting it by fitting into grooves on its underside, are 42″-high sections of ¾″ tempered glass meant to keep children from falling into a mudbank or a pool. Graphics on the handrail-mounted strip give the feeling of a biologist's field notes and include sketches of animals in the rain forest and even some hand written note-like identifications. The

designers applied these graphics by a process called Coloron, which they say will eventually be marketed under the tradename LetraChrome. It's essentially a process which uses a dye, fixed by light shining through a scrim onto a polyester-base paper. They laminated the paper to low-glare plexiglass in 16″ modules.

6.

Graphics in the explanatory galleries are more consciously conspicuous. Mounted on phototype panels, the largest of which is 4′ by 6′, they tell the rain forest story.

Also in these galleries are the small wall cases that hold ferrets, mice, lemurs, and slow loris that cannot safely be allowed loose in the large exhibit. The real walls of these cases are backlighted 35mm slides of natural habitats, blown up to 6′ by 12′ and fronted by plexiglass sheets.

One gallery (the rain forest introduction gallery) is lighted as if by moonlight. Against one wall stands a 28′-high silhouette, in three dimensions, of trees, plants and vines. From the lavender and deep blue

ceiling, spotlights, mounted with screens in which leaf patterns are cut, throw leaf patterns on the carpet. On one wall, butterflies mounted on darkened piano wire and seen through smoked glass appear to float and swarm.

Out in the rain forest, the designers built what they call a Jungle Lab, a concrete and steel (to meet fire codes) room, clad in bamboo and wood and decorated with binoculars, lanterns and microscopes to look like a field biologist's lair. The 22′-by-23′ room holds a continuous stream of school groups (by appointment), who listen to lectures on rain forests and conservation or perhaps even a talk by John Gwynne on how to build a jungle habitat.

While listening, the children can look out the windows at the jungle and see monkeys playing or perhaps a hornbill with a 6′ wingspan swoop by.

"The public seems astonished and delighted," says John Gwynne, "and is even reading our messages, absorbing our conservation themes."

And the public is trooping in. By the time JungleWorld had been open just 18 days, its 100,000th visitor had passed through, and it expects to draw a million people a year.

What has pleased the designers is that, even with these numbers, the million cubic feet of space beneath 55′ ceilings has not yet seemed crowded.

**Client:** New York Zoological Society (Bronx, NY)
**Sponsors:** Enid A. Haupt (major donor); Chase Manhattan Bank; others
**Design firm:** Exhibition and Graphic Arts Dept., New York Zoological Society, Bronx, NY
**Designers:** Dr. William Conway (general director, New York Zoological Society), John Gwynne (curator, Exhibitions and Graphic Arts Dept.), Charles Beier (associate curator, EGAD), Walter Deichmann (senior exhibitions designer), Sharon Kramer, Curtis Tow (graphic designers), Deborah Ross ("field sketch" illustrator), John Challis, Jonquil Rock, David Rock, Lawrence Dietterich (foreman of Larson Co., exhibit fabricators), Timothy Hohn (horticulturist)
**Consultants:** Howard Brandston (lighting), Pam Amster (photo research), Dr. Jill Cowen (fine arts), Herbert Reimer (architect)
**Fabricator:** Larson Co.

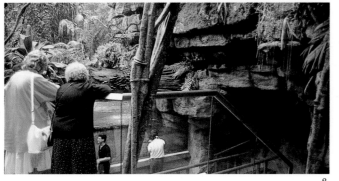

7.

9.

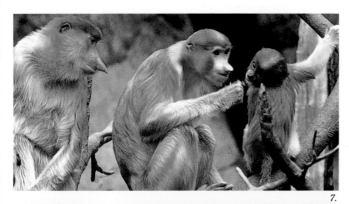

8.

10.

4. *Exhibit entrance displays Javanese and Indian silk banners and graphics of rain-forest flora and fauna.*
5. *At exhibit exit, counter records minute-by-minute loss of rain forest habitat.*
6. *Drawing of white-handed gibbon, inhabitant of JungleWorld.*
7. *Proboscis monkeys take to their artificial home.*
8. *Visitors move through the rain forest environment on raised walkway.*
9. *Entering the lower montaine rain forest.*
10. *Handrail-mounted graphics include sketches and notes on 16″ plexiglass modules, slipped into brackets on the railing.*

# The Folding Image: Screens by Western Artists of the 19th and 20th Centuries

Forty-three examples of Western screen-makers' art, culled from more than 250 pieces in public and private collections in the U.S. and Europe, were on display for six months at the National Gallery of Art in Washington, D.C.

Folding screens, painted or carved on one or both sides and meant as space dividers as well as works of art, were a Chinese invention which the Japanese modified. Among other things, the Japanese devised a hanging technique that let an artist treat all of a screen's sections as a continuous surface. But not until the mid-19th century did these Oriental screens become plentiful and well-known enough in Europe for major Western artists and designers to begin experimenting with screens of their own.

Not all the screens in the National Gallery's exhibition were the work of painters. One, for instance, was done by the English designer William Morris, using wall hangings he had embroidered; another was by Spanish architect Antonio Gaudí. Included, too, were a stained-glass screen by Louis Comfort Tiffany and a four-panel, double-sided screen by American photographer Ansel Adams. Patsy Norvell's screen, "Jungle Wall," had panels shaped like the leaves etched on them. Some of the screens were a sort of functional sculpture. Eileen Gray's "Block Screen," done in the early 1920s of lacquered wooden blocks mounted on vertical aluminum rods, is arguably more sculpture than screen, though it can, like Gaudí's contorted oak and glass panels, function as a transparent space divider.

The National Gallery's Design and Installation Department knew it would have to treat the screens as paintings, as sculpture and as space-dividers if the exhibit were to work. But what wasn't immediately realized was that the screens need lots of space. The designers tried arranging them first in a 7000-sq.-ft. gallery, but ended up postponing the exhibit slightly so that the screens could go instead to the East Wing concourse, where they could have close to 15,000 sq. ft.

Gil Ravenel, chief of the Design and Installation Department, and his designers opened up the space completely, taking out all the temporary walls and partitions, leaving only (because they had to) a central, triangular elevator and electrical-duct core.

They gave each screen its own platform, elevating it 6″ to 2′ off the floor, and Ravenel used the walls of this central core as a backdrop for some of the screens, pushing the platforms right up against it, and in two instances creating niches in the core so that the screens could be recessed slightly.

Throughout the rest of the area, the designers used the screens to give the space shape, pushing screens and their platforms against the walls or out into the concourse, where visitors could walk around screens that had both sides painted. But always the design kept sight lines open, so that a large part of the exhibit was visible from any location within it.

Moreover, the screens were positioned so that their shapes

1.

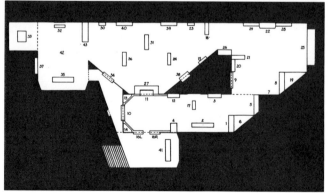

2.

and colors would play on one another. And some of the screens were grouped because their fragility allowed them only subdued light. Some were grouped historically, but all 43 had plenty of space (an average of 348 sq. ft. per screen) beneath the concourse's 16′ black ceiling.

All the screens were individually lighted to stand out against the dark walls and the charcoal gray carpet. Lighting designer Gordon Anson retracked all the ceiling lighting (as he does for each National Gallery show) so that the tracks were parallel to the objects displayed.

The designers' most difficult problem was to relate each screen's particular geometry to that of those around it and, at the same time, to relate each screen to the space. Initially, they did this by constructing 1″ scale models of each screen and moving them about on a plan of the space until they felt they had the right configurations, juxtapositions and sight lines.

All the platforms were prefabricated of plywood, carried into the gallery and screwed to the concrete floor so that they wouldn't move if inadvertently bumped by a visitor.

The platforms were painted shades of gray and blue, and information about each piece was silk-screened directly on its platform.

The National Gallery's Design and Installation Department designed and put the exhibit in place in six months.

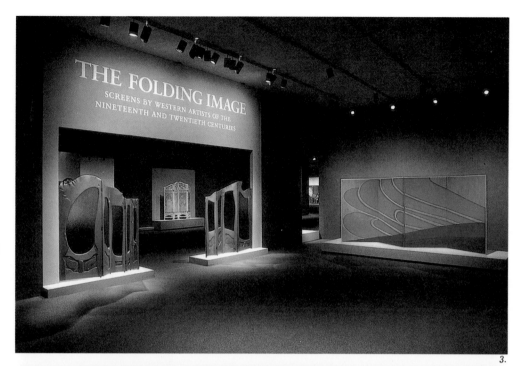

3.

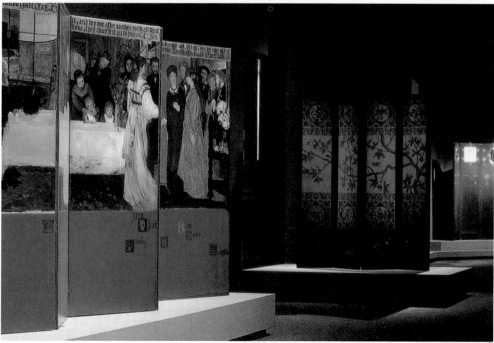

4.

1. Exhibition poster.
2. Floor plan shows position of each of 43 screens. Numbers match catalogue listing.
3. Wooden screens by Antonio Gaudí flank exhibit entrance. Opening between wall partitions lets visitors glimpse part of the exhibit beyond.
4. Each screen has its own pedestal and its own space. But some also partition the space, as they were designed to do.

**Client:** National Gallery of Art
(Washington, DC)
**Sponsoring organizations:** Bankers
Trust Co., Goldman Sachs & Co.
**Design firm:** Design and Installation
Dept., National Gallery of Art
**Designers:** Gaillard F. Ravenel, Mark
Leithauser, Gordon Anson (lighting)
**Guest curators:** Michael Komanecky,
Virginia Butera
**Fabricator:** National Gallery of Art
exhibit shop

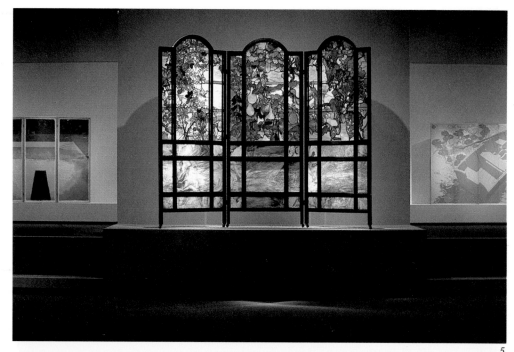

5.

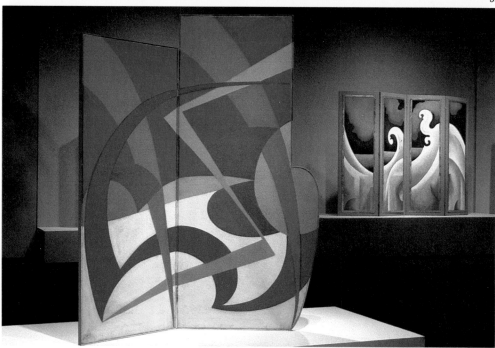

5. *Stained-glass screen by Louis Comfort
   Tiffany, his only known three-panel
   folding sceen.*
6. *Screen by Giacomo Balla in front of
   one by Thomas Hart Benton with four
   panels.*

6.

# Wonderwall

Like a stage set for a fantastic dream, Wonderwall cascaded 2500′ straight down the central axis of the 1984 Louisiana World Exposition, between the two main gates. R. Allen Eskew, lead architect on the project for Perez Associates, the architectural firm that served as executive architect and master planner for the Fair, said he wanted the wall to fit with his idea of the exposition as, like New Orleans itself, "gumbo, not souffle." Charles Moore of Charles Moore/William Turnbull, who first conceived of Wonderwall, called it an "architectural tantrum," and the *Casebook* jurors called it variously, "sophisticated," "rich," "significant," "playful," and "appropriate." In a sense, Wonderwall, with its twinkling lights, its jumble of giant animal shapes and architectural elements hung like Christmas-tree ornaments on a steel scaffolding, set the mood for the 1984 New Orleans World's Fair, and as such the jurors singled it out as the best-designed element of the exposition and as an outstanding example of current exhibit design.

Certainly, Wonderwall was symbolic of what American architecture and design are free to embody in the 1980s, and although the rest of the Fair, for a variety of reasons, did not live up to Wonderwall's standards (or even its mood), that is beside the point. Wonderwall went through a good deal of the financial turmoil (including massive over-all budget cuts) that roiled the Fair. The wall's original $10-million budget

ended up being $3.8 million. But its design survived.

It came about this way.

Charles Moore was in New Orleans talking to Perez Associates about the design of one of the Exposition's theme buildings ("The World of Rivers: Fresh Water as a Source of Life"), when the discussion got around to the power lines that ran straight through the site, cutting it in half. Moore said *he'd* create an architectural temper tantrum right in the middle of the street. Wonderwall was an embodiment of this tantrum. And not only did it take visitors' eyes and thoughts off the power lines, it also provided space within its structure for some 50 shops operated by vendors.

Arthur Andersson, the Charles Moore/William Turnbull architect who with Leonard Salvato of Perez Associates did most of the actual design work on the "tantrum," says Wonderwall was like a midway turned in on itself. "It was like the midway at Coney Island, only you didn't really go into it, you passed it by. You could see through it to the other side."

The architects created poured-concrete platforms, 10′ square, alternating with 24′-long bays; the 10′-square platforms were to be for fountains, and some of the fountains materialized despite the budget cuts. The 24′-long

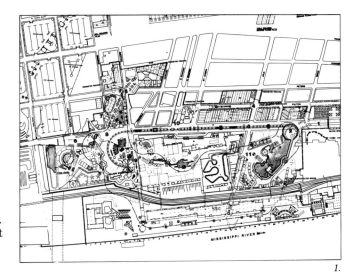

1.

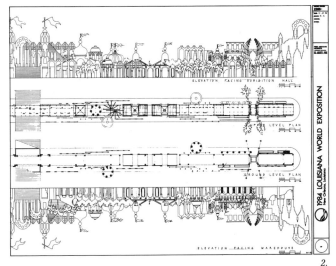

2.

1. *Master plan of 1984 Louisiana World Exposition. Wonderwall outlined in red.*
2. *Wonderwall elevations and plans (upper and lower levels).*
3. *Rendering of concept for Wonderwall segment.*

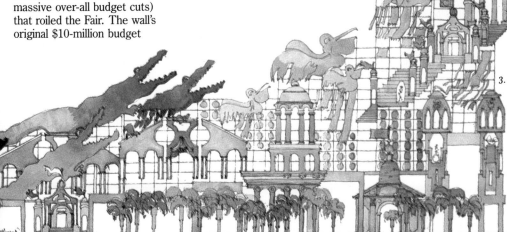

3.

bays were to shelter vendors, and vendors eventually rented 70 per cent of them. In the concrete slabs the architects embedded steel feet, and onto these feet they fit the open ends of a rented construction scaffolding. This scaffolding undulated vertically through the site, rising as much as 90′ above the street at one point, but mostly it could go no higher than 35′ because of the power lines. Onto the scaffolding the artchitects hung the welter of shapes, images and lights that provided the wonder. "It was sort of like the Spina in Rome," says Arthur Andersson, speaking of the barrier running up the center of a Roman circus.

The architects designed 20 different shapes: animals, such as pelicans (cut from 4′-by-8′ plywood) and alligators; architectural forms, such as temples, loggias, and domes; and Chinese palms of telescoping metal drums on poles, with palms planted in the top drum. They had three kinds of domes (an onion dome, a lattice dome and an Arabic-like dome), three kinds of loggias, and three different temple shapes. They fabricated some 50 examples of each shape using varying materials—styrofoam, corrugated plastic and metal, and wire lath (one alligator was made out of sandbags filled with cement)—and painted different colors from a palette of 40 colors, so each piece had an individual identity.

The architects hung these elements on the scaffolding or from a flat metal scrim with holes in it, which, in turn, hung on the scaffolding. They mixed

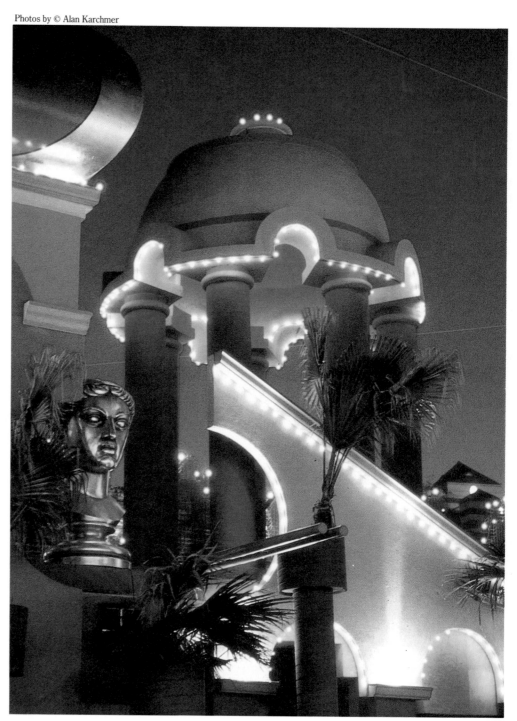

4.

5.

6.

4. Architectural elements were part of Wonderwall.
5. Bridge Gate sculptures set mood for Wonderwall.
6. Designers strung these elements on a rented construction scaffolding.
7. Wonderwall from street level. Wall was meant to take attention from overhead power lines.

elements and added others, such as plants and revolving house ventilators on stalks. "Like a Christmas tree, the more stuff we hung on it, the better it looked," says Arthur Andersson.

Though the design may sound haphazard, it was not. Andersson had rented a French Quarter apartment, one that was part of an old theater, and Andersson and Leonard Salvato laid the whole wall out in Andersson's 50′ living room. Using sticky-back tags, they determined what would go where in what sequence as the Wonderwall careened through the site.

Colors got brighter as they rose up the wall. From murky at the street to medium hue in the middle, they became bright at the top.

And finally, onto the shapes they strung strands of sparkling lights, like popcorn.

The name Wonderwall, which revealed itself to Charles Moore on a trip to Natchez, perfectly suits the wall's comic book-like look. Curator and art critic Henry Geldzahler has said that he often wondered what kind of art the generation that grew up on television would produce. Wonderwall is one answer.

**Client:** Louisiana World Exposition (New Orleans)
**Executive architect and master planner:** Perez Associates; Auguste Perez III, principal-in-charge
**Design firm:** Charles Moore/William Turnbull with Perez Associates/Studio Two (R. Allen Eskew, director)
**Designers:** Charles Moore, William Turnbull, Kent Bloomer, Arthur Andersson, Leonard Salvato
**Consultants:** Tina Beebe (color), Richard Peters (lighting)
**Fabricator:** Blaine Kern Artists

8.

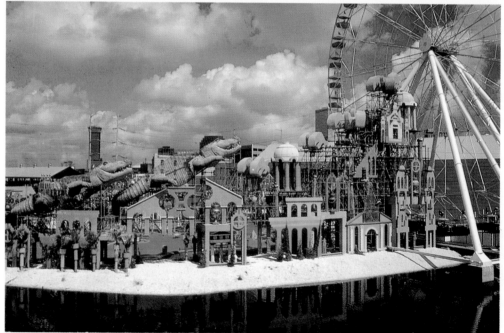

9.

8. *Watergate fountain with Wonderwall in background.*
9. *At its highest point, next to Ferris wheel, Wonderwall rose to 96′.*